The RIVER HAMBLE

A HISTORY

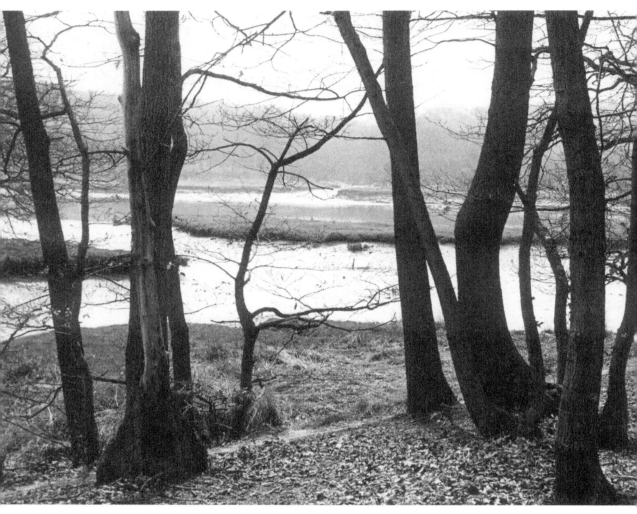

View of the Hamble from Fosters Coppice.

The
RIVER HAMBLE

A HISTORY

DAVID CHUN

The History Press

First published 2009 by Phillimore & Co. Ltd
This edition 2014

The History Press
The Mill, Brimscombe Port
Stroud, Gloucestershire, GL5 2QG
www.thehistorypress.co.uk

British Library Cataloguing in Publication Data.
A catalogue record for this book is available from the British Library.

ISBN 978 0 7524 9966 6

Typesetting and origination by The History Press
Printed in Great Britain

CONTENTS

List of Illustrations

ILLUSTRATION ACKNOWLEDGEMENTS
Illustration numbers in **bold**.

Anne Hayward / **93**; Author's Collection / **26, 43, 90, 91**; Bartolozzi (engraving after 1800 portrait by John Raphael Smith) / **29**; Botley & Curdridge Local History Society / **5, 17, 21, 22, 34, 35, 38, 92**, BCLHS77 / **54**, BCLHS CPIC 0078 / **20**, BCLHS PH019 / **18**, BCLHS PH073 / **31**, BCLHS PH128 / **39**, Courtesy of Dennis Stokes / **88**, BCLHS and Southampton University (Cope 43.14) / **44**; British Geological Survey, A14262 / **1**; Francis Grose, *The Antiquities of England and Wales* / **13**; Hampshire Record Office / **2, 11, 24, 36, 55**, 5M53/1128/4e / **19**, 29M67-13 / **37**, 41M89/151 / **41**, 44M73/E/P68 / **30**, 45M69/133 / **62**, 52M48/13 / **63**, 58A01/1 / **7**, 58A01/1 / **8**, 58A01/1 / **45**, 58A01/1 / **65**, 58A01/1 / **84**, 58A01/2/1 / **50**, 58A01/2/2 / **46**, 65M89/264/3 / **32**, 65M89/Z42/29 / **3**, 65M89/Z42/30 / **66**, 93M94/33 / **49**, 103M96/12 / **87**, 120M94W/E27 / **86**, 130M83/PZ13 / **6**, 130M83/PZ13 / **9**, 130M83/PZ13 / **25**, 130M83/PZ13 / **27**, 130M83/PZ13 / **42**, 130M83/PZ13 / **48**, 130M83/PZ13 / **51**, 130M83/ PZ13 / **60**, 130M83-PZ13 / **67**, 130M83/PZ13 / **82**, Photocopy 641-2 / **81**, TOP 037/2/2 / **28**, TOP Portraits M/10 / **23**; Hampshire & Wight Trust for Maritime Archaeology (HWTMA) / **40, 77**; National Maritime Museum, ADM 168/135 / **74**, BHC1096 / **10**, BHL 0478 / **73**, C9569-10 / **69**, Edward Dummer and Thomas Wiltshaw, *A Survey of the Ports of the South West of England from Dover to Land's End, 1698* / **70**, N14307 B / **89**, P/34A(19) / **70**, PAF1025 / **94**, ZAZ1070 / **75**; National Portrait Gallery, 545 / **68**, 1154 / **64**, 2561 / **33**; H.C. Oakley, 1889 Hampshire Field Club Proceedings / **59**, 1894 Volume / **61, 85**; Roger Pearce / **4, 47**; Royal Naval Museum, Portsmouth / **76**; Southampton City Library / **71**; Charles F. Fox (or son), *The Antiquaries Journal* / **57**; University of Southampton, Cope, Ph 622 BURS 91.5 / **53**, Cope Ph 628 BURS 91.5 / **95**, J.T. Eltringham, 1907, Cope, BURS 67 / **83**; Westbury Manor Museum/Fareham / **56, 58**; Bryan Woodford / **79**; Reproduced by kind permission of Mrs Nichola Gottelier / **52**.

ACKNOWLEDGEMENTS

A book, even a modest one such as this, creates debts for the author. The material on which it is based has been gathered during the period of over twenty years that I have lived in the Hamble valley. The late John Hogg of the Botley and Curdridge History Society was one of the first people I met who shared my interest in the Hamble river. I still remember with gratitude his many kindnesses to me in providing information and encouragement. I have used some of his research in the chapter on the river trade, and like to think that he would have approved of the use I have made of it. I am grateful to the Botley and Curdridge History Society for permission to reproduce a number of photographs in their collection. Dennis Stokes, a stalwart of that Society, has been particularly helpful in supplying copies of photographs and other information. He was also kind enough to read and comment on a draft of my text. Paul Donohue of the Hampshire and Wight Trust for Maritime Archaeology also read an early draft, and he and Julie Satchell of the Trust have been very helpful is supplying information. I am grateful to all of the many institutions that have permitted me to reproduce illustrations in their collections, and answered my queries. Sarah Lewin and Linda Champ of the Hampshire Record Office have been particularly helpful in this regard. They, and the other members of the Record Office staff, have been unfailingly helpful and courteous to me during the years I researched the material for this book. Tom de Wit of the Westbury Manor Museum in Fareham has also taken a great deal of trouble in providing photographs of items in the Museum. My friends Barbara Biddell and Kevan Bundell also read drafts of this book and made helpful comments and, in Barbara's case, provided illustrations and information. I am also grateful to Bryan Woodford who kindly supplied a copy of an early photograph of the Warsash waterfront. Last, but not least, I must thank my family, Mandy, Philippa and William, who put up with my many absences in 'The Outhouse' working on this book.

INTRODUCTION

THE VALLEY

In terms of the almost dizzying lengths of geological time and process, the Hamble River flows through a relatively young landscape. It did not take on its present form until about 6,000 to 7,000 years ago when, in the last of a series of great inundations – the Flandrian transgression, the valley of the ancient Solent River was invaded by the sea. Southampton Water was created and the lower reaches of the Hamble, previously a tributary of the now drowned river, was given its present estuarine character. This was long after our prehistoric ancestors had first begun to frequent the Solent region.

The Hamble rises on the chalk formed in the Cretaceous Period (146 to 65 million years ago) but for much of its 12-mile length flows through a valley formed of Tertiary deposits – largely clays and sands – that were laid down in a great trough, or syncline, in the chalk (hence the term Hampshire Basin) during the Palaeogene Period, some 65 to 23 million years ago. Throughout this time the sea level periodically rose and fell. At times the sediment that was to form the clays and sands was laid down in a shallow sea, as evidenced by the sharks' teeth and other marine fossils found at West End; at other times, when the sea was for a time excluded, these were formed in estuarine conditions or in fresh water.

London Clay, Bagshot Sands and Bracklesham Beds are the principal components of these Tertiary deposits that form the solid geology of much of the valley. Overlying these are the 'drift' deposits – the brick-earth, clay with flints and, most significantly,

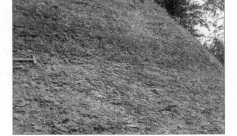

1 *Photograph of clay in Swanwick Brickworks.*

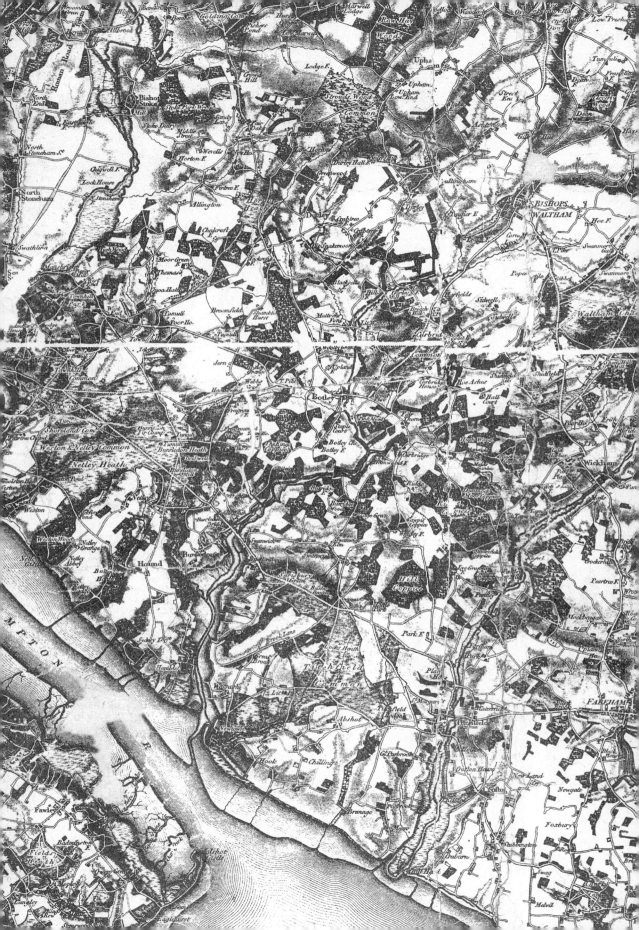

gravel. These later deposits are probably a legacy of the Ice Age (Pleistocene Epoch of the Quaternary Period), when, during three glacial phases, great sheets of ice covered much of the British Isles. Although these did not directly affect southern England, it would have been subjected to tundra conditions. Each spring large quantities of material would have been washed down braided (multi-channelled) rivers and, according to current thinking, this formed the coastal plateau that includes the land on both sides of the Hamble below a line represented roughly by that of the A27 road.

The underlying geology and the resultant soils assist our understanding of the present-day valley, both the river and the landscape through which it flows. And, with the geology in mind, it is convenient to divide the valley into sections. It has been observed that the estuary of the Hamble is unusually long given the river's overall length, and the section of the tidal river below Bursledon can be contrasted with that above the M27. The non-tidal river above Botley meanwhile has its own quite distinct character.

Below the Bursledon Bridge, which carries the A27 across the water, there is greater commercial and recreational activity than elsewhere on the river. But while there are marinas and pontoons, and, therefore, more boats than upriver, the areas of saltmarsh on the east bank – Lincegrove and Hackett's Marshes – and prominent areas of woodland, such as Cawte's and Downkiln Copses, still provide a sense of space, if not of wildness and relative isolation like the river above Bursledon. As the river is wider here, one is more conscious of the open sky. This section of the estuary flows through the previously described largely flat coastal plain. These terraces of gravel, a legacy of the Quaternary, provide well-drained and productive farmland used for arable production, market gardening and horticulture. Once the valley was a great strawberry-growing area, and the fruit grown here was prized for the 'earliness' of its cropping; with strawberries typically being picked two weeks earlier than in Kent. It also provided good building land: the 'hoggin' gravel provided secure foundations, and much land has been lost to development, particularly on the Warsash side of the river.

Above Bursledon, the valley has a quieter character. The river here flows through, in landscape terms, an older countryside. The field pattern is more irregular and there is a greater area of ancient woodland; it is a bocage terrain, the 'clay and coppice' countryside that Botley farmer William Cobbett favoured. The soils are heavier too, large areas being on

2 *First edition of one-inch Ordnance Survey showing the whole length of the valley from Bishop's Waltham to Southampton Water.*

3 *Distant view of old bridge looking up valley, c.1908.*

4 *Estuary from west bank of river above Bursledon.*

the stiff London Clay, particularly on the eastern bank, with more land being given over to grazing, though there is still some arable production and horticulture. The riverside land is largely undeveloped and the ancient woodland in places runs down to the water's edge; again there are pockets of salt-marsh and reed-beds. As we shall see, this section of the river has long since been prized for its natural beauty and, despite the hum of traffic along the M27, still has, in certain seasons and times of the day, a surprisingly unspoilt quality.

Botley, where, as Cobbett noted, fresh water 'falls' into the salt water, marks the upper limit of the tidal river. The non-tidal river above Botley flows through a narrow valley largely given over to improved pasture and woodland. The historical function of this part of the river was to provide water power to drive the several corn mills (and one paper mill) that once existed between Botley and Bishop's Waltham, just above which the river rises. This section of the river has suffered from water being taken for the public supply. As we shall see, by the last century there was insufficient flow of water to drive the mills, and in the dry summer of 2006 *The Times* reported that the river here had, temporarily at least, ceased to flow.

The main river is not the whole story, of course. More than thirty streams and rivulets, which drain the surrounding countryside, feed into

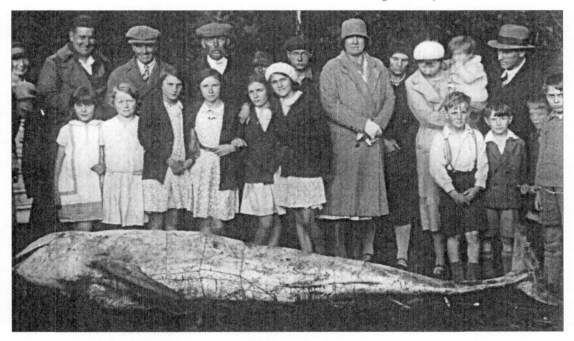

5 *Photograph showing the Curbridge 'whale'. It was found in Curbridge Creek on 2 August 1932 where it was seen by 5,000 people. At the time it was identified as beluga or white whale. Modern research, though, suggests that it was actually Risso's Dolphin,* Grampus griseus.

it. The headwaters rise on the chalk, where there are numerous springs. The source of the river is taken as being at Northbrook, just to the north of Bishop's Waltham, but soon it is augmented by another large stream that rises at The Moors, an area of wetland to the east of the town. This is the first of a series of large streams that flow into the main channel. Many of them include in their names the denominative 'Lake' – Ford Lake (the chisel-bourne or gravelly-stream of the Anglo-Saxon land charter for Durley of A.D. 900), Shawfords Lake and Pudbrook Lake. The term 'lake' apparently derives from the Old English for a small stream or watercourse, not the modern word 'lake' that comes from the French. However, to anyone who has seen one of these streams in full spate in winter, brimming over its banks after days of heavy rain, the latter sense seems entirely apt. This is another effect of the geology. There is rapid run-off from the Tertiary streams – the impermeable clays are unable to absorb heavy rainfall – and the sediment carried down by the streams re-charges the mud of the estuary.

Man has had a presence in this valley for many hundreds of thousands of years. The first people to frequent it would have led a nomadic existence, sustaining themselves by hunting and fishing. Hand-axes, made from knapped flint, have been found at Warsash – indicating human presence in the valley in the Lower Palaeolithic, hundreds of thousands of years ago, long before rising sea levels caused the lower estuary to take on its present form and when Britain was still connected to mainland Europe. Other evidence of man's early activities in the valley is scattered all along its length. There have been discovered, in gravel workings at Fleetend and Hook, close to Warsash,

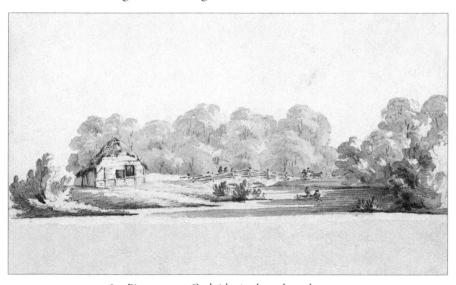

6 *River scene at Curbridge in the early 19th century.*

field systems and other evidence of continuous occupation from the Bronze Age into the medieval period. A Bronze-Age burial pit was discovered at the brickworks at Swanwick in 1927 and the earthworks of an Iron-Age fort can still be seen on Hamble Common. The Roman occupation is represented by a villa complex, which has been partially excavated at Fairthorn, at the confluence of the Hamble with Curbridge Creek, close to the Roman road that crossed the river at this point.

In the Anglo-Saxon period the river has a more tangible presence: by then it has a name. The Venerable Bede, writing in *A History of the English Church and People* of about A.D. 731, describes the River Homelea as entering 'the sea after flowing through lands of the Jutes who lived in the Gewissae country ...' The name, unlike that of other Hampshire rivers, appears to have a Germanic origin, indicating that it was bestowed by the Anglo-Saxon migrants who arrived in southern England after the collapse of the Roman Empire. The name means 'maimed' or 'crooked', which almost certainly alludes to the river's winding course and, in particular, the great bend at Bursledon. Interestingly, there is a river called Hammel in Germany, a tributary of the Weser.

With the compilation of Domesday Book in 1086 we can start to fill in some of the blank spaces of the river's hinterland. It records settlements at Hound, Netley, Botley and Bishop's Waltham and several on the coastal plain to the east of the river, including Titchfield, Hook and Brownwich. The presence of three pre-Conquest -ley place-names, those of Durley, Botley and Netley, which means an inhabited clearing in woodland, suggests that parts of the valley were well-wooded in the Anglo-Saxon period. Domesday Book, for this part of Hampshire, is not as helpful as it might have been in recording woodland cover. Not only is it a swine-rent county, where woodlands are recorded by the number of swine they could sustain rather than by area, which makes the extent of woodland hard to quantify, but some of the entries for woodland are confusing. Whereas Netley is shown as having woodland for 40 swine, a relatively large number, the entry for Botley records that there is no woodland; this hardly tallies with the records of extensive woodland in later centuries, or indeed with the extent of ancient woodland that survives today. The explanation may be that the woodland belonged to the King, being part of the Forest of Bere, which stretched westwards to Southampton, and thus not taxable in the hands of his subjects.

Hamble, Warsash and Bursledon, though not mentioned in Domesday Book, were medieval settlements. By the early Middle Ages the pattern of village, farmland, woodland and heathland was established, and probably did not alter greatly until the great heaths of the district – such as Botley Common (enclosed in about 1815), Titchfield and Swanwick Commons (enclosed in about 1859) – and much woodland was destroyed in the 19th

7 *View of the Hamble from Elm Lodge at Bursledon in the 1890s.*

century. More farmland and further woodland has been lost to development in the last century. A reminder of the heathland is provided by the sometimes extensive patches of gorse and broom that can still be seen on the sides of the motorway and in other odd corners.

In most respects the valley has been congenial to human occupation. Sheltered in the lee of the Isle of Wight, it generally enjoys mild winters and warm summers, with few frosts and little snowfall. This is not to suggest that the area has been entirely immune from extreme weather conditions. A 'most violent gale of wind' in February 1776 damaged shipping and seaside buildings on the Solent and carried away great quantities of timber, tar and salt at Bursledon, as well as at Redbridge and Hythe. Almost exactly a year later, extremely cold weather, which was considered to be even more severe than the hard frost of 1740, affected the area and caused the Hamble, along with the Itchen, to be 'entirely frozen over', so that 'inconsiderate' people were able to cross it without injury. The river appears to have frozen again in the hard winter of 1894/5. On Boxing Day 1886, an 'indescribably dark evening', torrential rain, perhaps combined with a high tide, caused extensive flooding at Botley, affecting the wharf area. Sacks of wheat and, according to estimates at the time, about 200 tons of coal, were washed into the river, the cellar

of a house was also flooded and two horses drowned in their stable. Several tons of coal were apparently recovered from the river during the First World War, a time of national shortage. In more recent memory, there was a bitterly cold winter in 1962-3. But the general impression is of a temperate climate, dominated by the westerlies of the Atlantic weather system. Cobbett noted this and, sharp-eyed as ever, also observed how oak trees on the Hampshire coast are shaved of branches on their south-west sides by the prevailing wind.

It was not only climatically that the valley had advantages for its inhabitants, but in economic terms also. The archaeologist, Barry Cunliffe, has claimed that the estuary of the Hamble, like those of the Beaulieu and Lymington rivers, never developed as a port, unlike those at Poole, Christchurch and Southampton, because 'as routes to the interior they were insignificant, petering out in forests and heathland'. This is no doubt true, but the river's local, as opposed to regional significance, should not be discounted. As will be seen in later chapters, the Hamble had coastal ports in Bursledon, Hook, Hamble and Warsash, and indeed Botley in the more recent past; there were valuable quantities of timber, for building and shipbuilding, in the valley, as well as materials for making bricks and tiles.

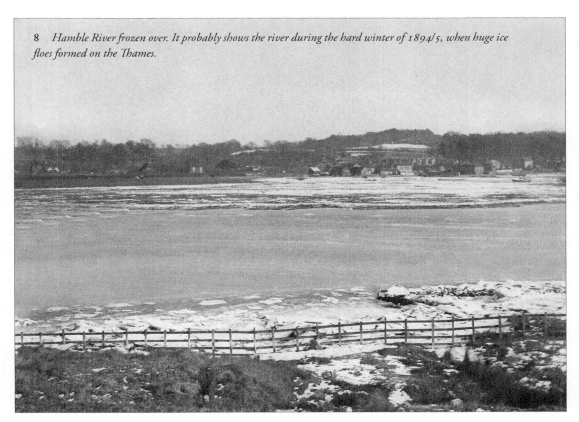

8 *Hamble River frozen over. It probably shows the river during the hard winter of 1894/5, when huge ice floes formed on the Thames.*

Salt could be manufactured from evaporated seawater, and this process was carried on from the medieval period until the beginning of the 19th century. All these industries provided a variety of employments: in the timber and underwood trades, fishing, the coastal trade, as well as farming. The estuary would have witnessed the types of bustling river scenes that we are familiar with from art since the Renaissance: trading vessels; ferries; ships being built on the river's banks and smoke rising from iron furnaces.

The military significance of the valley, on the 'bulwark' coast along the English Channel water facing Europe, should also not be overlooked. Throughout the last thousand years, it has been, if not the site of great events, then of preparations for them. Indeed at times it must have seemed like a gigantic transit camp. Henry V's fleet sailed from the river in 1415 for the Agincourt Campaign and the wars with France saw armies encamped on the then wild expanse of Netley Common ready for embarkation – in 1794 for the expedition to the Low Countries, and in 1800 by part of Sir Ralph Abercromby's force of 20,000 troops that eventually won a hard-fought victory in Egypt. Such assemblies seem to have been the occasion for an 'evening line that was formed on this elevated spot, resounding with military music, graced with the smiles of beauty, and cheered by the holyday

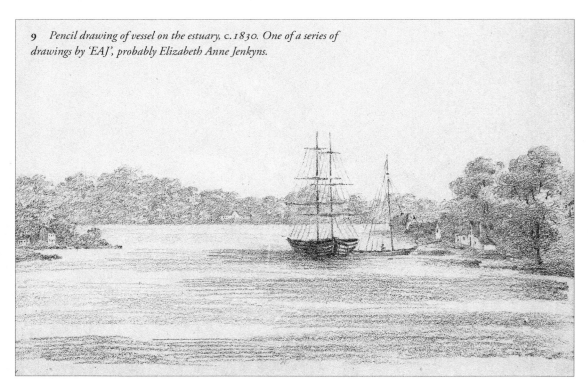

9　*Pencil drawing of vessel on the estuary, c.1830. One of a series of drawings by 'EAJ', probably Elizabeth Anne Jenkyns.*

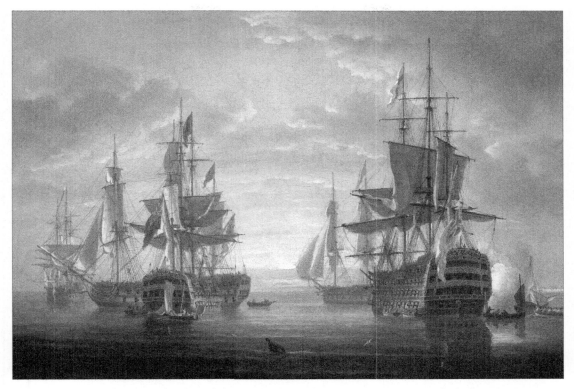

10 Nelson's Flagships at Anchor *by Nicholas Pocock, 1807. It shows* Agamemnon, Vanguard, Elephant *(in stern view on the left),* Captain *and* Victory. *The* Elephant *was built at Bursledon, being launched in 1786.*

attendance of festive multitudes' like the one recalled in this 1819 account. Such scenes of military preparation were repeated in the area, and on a more epic scale, at the time of the Normandy landings of 1944.

Today the Hamble is a leisure river, and at the beginning of the 21st century its valley threatened by the kind of subtopian development that Philip Hoare describes in his fine book about Netley Hospital, *Spike Island*: 'Subsumed by light industry, yachting marinas and modern estates, it is a place of retreat and recreation; a faithless culture that seems to have no other aim than the nearest shopping opportunity.' That the valley has not all been as heavily developed as the area around Netley is not always a consolation. At times the relict countryside can seem a slightly irrelevant backdrop to a reality of concrete and tarmac – but there are reminders of an older world still. Fine buildings and areas of attractive countryside survive. And this book is essentially concerned with that older world, and an earlier set of relationships with the river: the valley before motorways and superstores, before marinas and golf courses, even before bridges.

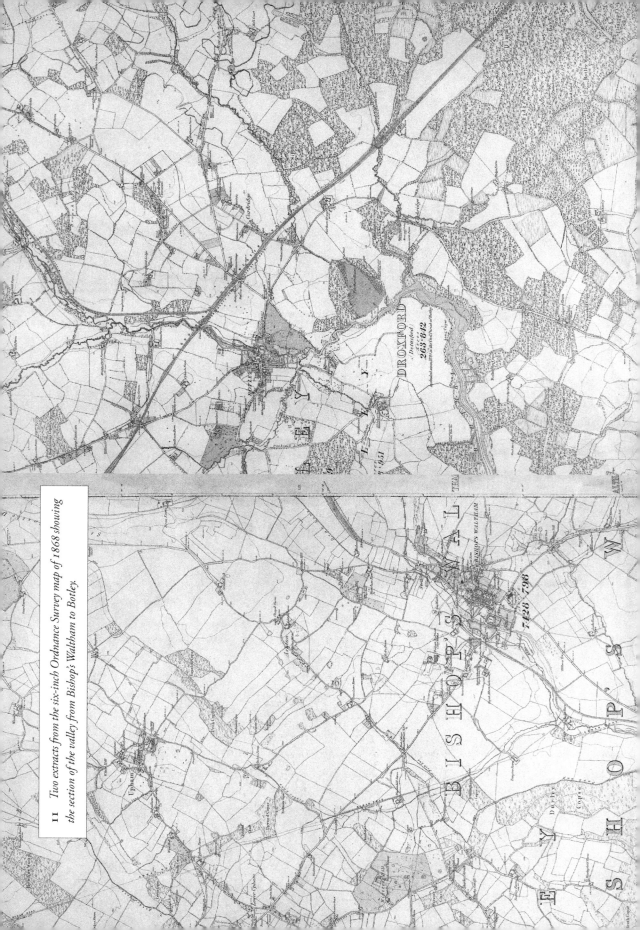

11 *Two extracts from the six-inch Ordnance Survey map of 1868 showing
 the section of the valley from Bishop's Waltham to Botley*

PART ONE

The Bishop's River: Bishop's Waltham to Botley

AROUND THE SOURCE

A river's mouth is self-evident. Its source is less easy to place, and may even be the subject of at least antiquarian speculation. The Hamble River is formed by the coming-together of two streams that flow from the west and east of Bishop's Waltham, and which are shown as a neat snake's tongue on John Blaeu's map of 1645. It is helpful that the stream that flows from the west of Bishop's Waltham is fixed by the minor place name of Northbrook, probably meaning 'north of the brook', because this section of the river, now dried up as a result of water abstraction, is normally taken as the source of the Hamble. The 1840 tithe map for Bishop's Waltham shows a continuous area of water having its origin at Water Lane Farm and flowing south first down one side of Water Lane before entering a culvert and continuing down the other side.

Arguments about the precise source of the river aside, it can be said with confidence that the Hamble originates in the spring line that marks the transition from the chalk downland to the clay land of the valley, and there is a welter of springs and wells in this area as well as watery place names: Water Lane, Northbrook and two fields called Spring Close. Northbrook stream flows into the Bishop's Waltham pond and, on emerging on the southern side, is joined by another small watercourse, historically called the Lord's river. This was, it seems, a 12th-century diversion of the main stream to take water into the moat of Bishop's Waltham Palace. About half a mile downstream from the Palace ruins, the stream is augmented by another large stream that flows from Wintershill to the west. A similar distance further on it is joined by its main easterly branch that rises at The Moors, a wetland area of carr, woodland and pasture that has been a nature reserve since 1994 – and we are now on the Hamble proper.

Nearly the whole of the river valley between Bishop's Waltham to the tidal limit at Botley was historically under the sway of the Bishops of Winchester who, since 904, were lords of the manor of Bishop's Waltham. From Domesday Book we know that there was a 'park for wild animals', one

12 *Park Lug: 20th-century photograph.*

of only 35 hunting parks recorded in the whole survey. This park covered
1,000 acres and large sections of its enclosure, called the Park Lug, survive.
This large earthen bank and ditch would have been surmounted by a stout
wood fence (the pale) to contain the deer. It seems that the park would have
been compartmentalised – into a Great Park and Little Park – so that, as
the Pipe Rolls record, two species of deer, the red and the fallow, could be
kept in it.

This park would have dominated the landscape to the south-west of
Bishop's Waltham for over six hundred years. Within the park pale, a
substantial feature in its own right, we can envisage a mixed landscape
of trees and grassland. The presence of wooded areas is attested to by the
felling of timber in the park in 1355-6 for building work at Wolvesey
Palace, another of the episcopal residences. There is a reference in 1352-3
to pigs being driven from East Meon to the park to feed on beech mast
there, but there were also open areas, called launds, where the deer would
have grazed. The presence of the Hamble River and its tributary streams
within the park meant that there was an ample supply of water for the
deer and it was not necessary to have man-made ponds. It also explains
how, in 1248, Jordan the Hunter was, as is recorded, able to catch two
otters there.

The park, once an important part of the medieval economy, though as
much a venison farm as a hunting area, had become an anachronism by the
17th century. It was disparked in 1663 and converted into farmland. It is
likely that Tangier, the name of one of the farms on the site of the original
park, takes its name from the coastal city in North Africa, which had been

captured in 1661 by Charles II's forces. The older use of the land survives in the name Lodge Farm, perhaps the site of the Keeper's house.

Though the park has gone, another part of the medieval landscape survives, albeit in a diminished form. The palace pond, now divided into two by the construction of the Bishop's Waltham bypass in the 1960s, was the Bishop's Great Pond formed by impounding the Hamble. This pond and the Lower Pond, which was just to the south of the present pond, supplied such fish as pike, tench and roach for the bishop's table and, during a period when the bishopric was vacant, for that of King Henry III. The fish were caught by the bishop's fishermen with the assistance of a seine net and rowing boat. Lower Pond had been drained by 1777, converted into meadows called Flowces and Penstock; the latter meaning 'a sluice', the former may also refer to the former use, or at least the wetness of the ground. The Great Pond was still valued as a fishpond long after the Lower Pond had been drained, being leased out for this purpose by later bishops.

This part of the valley did not just support vert and venison and provide fish; it also, as will be seen from the next chapter, drove the various mills along this part of its length. Also, in later centuries at least, its waters were

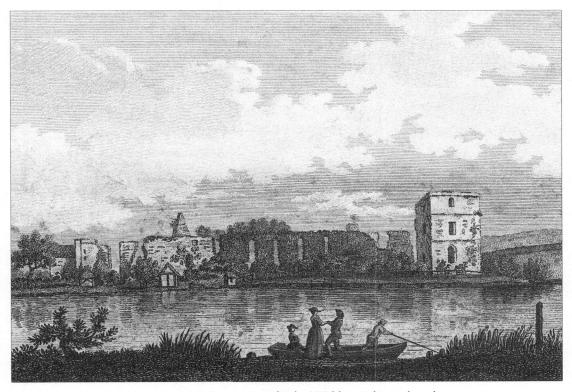

13 *A 1784 engraving of Bishop's Waltham Palace and pond.*

allowed to overflow and enrich farmers' fields. The mills have now stopped working, or disappeared altogether, but the character of the valley here is still agricultural, given over largely to pasture for livestock but interspersed, in the summer of 2006 at least, with a few fields of maize and sunflowers. The river is an almost nondescript feature, at least until it is reinforced from the discharge from the sewage treatment works at Brooklands, but there is – something of a rare survival in the modern countryside – a ford just upstream from the works. A railway branch line was made between Botley and Bishop's Waltham through this quiet farmland in the 1860s. Although to some extent the railway helped the development of industry around Bishop's Waltham, it lasted less than a hundred years; the line ceased to carry passengers in 1933 and goods in 1963.

But even in this quiet rural backwater there are, as in most parts of this small country, at least peripheral reminders of the wider history. St Willibald (c.700-87?) set off from Bishop's Waltham on his pilgrimage to Rome and subsequent travels in the eastern Mediterranean, sailing from the mouth of

14 *Ford south of Locks Farm, near Bishop's Waltham.*

15 *A steam train on Botley-Bishop's Waltham line.*

the Hamble in 720. As a child he was entrusted to the care of Abbot Ecgwald, at an otherwise unknown monastery at Bishop's Waltham. He later carried out missionary work in Germany, where the structures of the church were weak and the people had lapsed into apostasy, and he later became Bishop of Eichstätt. We can try to imagine that last journey along the wooded valley – he appears never to have returned to England – to embark at the haven.

Another cleric, Gilbert White (1720-93) is not remembered as a churchman but as a naturalist. He was curate at Durley from 1753, but only held the position for a year and a half and appears to have spent little time there. He had lodgings in the vicarage and commuted between Durley and Selborne on his horse, Mouse. He appears to have left no record of the countryside of the area, only mentioning in *The Natural History of Selborne* the Waltham Blacks, who killed and stole the Bishop of Winchester's deer in Waltham Chase in the 1720s. According to White, no young person was possessed of manhood or gallantry unless he was a 'hunter', though recent research suggests that the Waltham Blacks were motivated by more than a sort of 18th-century machismo or even just animus towards the bishop. Bishop's Waltham was James II's 'little Green Town', which was bedecked with greenery when he travelled through it to signal the townspeople's loyalty to the Stuarts. And it has been suggested that Bishop's Waltham may have been a hotbed of Jacobitism and the Waltham Blacks rebels, or at least sympathisers, to the Jacobite cause.

The name of Frenchman's Bridge, which carries the Botley to Bishop's Waltham road across the stream that flows in from the Moors, reminds us of a more wide-ranging conflict. This bridge marked the southern limit to which Napoleonic prisoners of war could walk during the daylight hours – a curfew was imposed. A number of these prisoners of war, officers on parole, were quartered in Bishop's Waltham between 1793 and 1815, their number including Admiral Villeneuve, the commander of the French fleet defeated by Nelson at Trafalgar. He was, according to William Cobbett, 'poorly lodged, barely attended and not in good health'. Villeneuve initially resided at *The Crown* and later at Vernon Hill House, just to the north of Bishop's Waltham, which had once been the home of Admiral Edward Vernon, who had captured the Spanish fortress of Porto Bello in 1737. It seems somewhat surprising that large numbers of French prisoners of war, over a hundred at a time, should be kept such a short distance from the coast and the Portsmouth military-industrial complex. Indeed, in 1793 Lord Grenville, in response to a letter raising concerns about this from his brother the Marquess of Buckingham, conceded that, 'the prisoners on parole at Waltham ought to be ordered to a more inland quarter, for five miles from Gosport is surely too near our arsenal.' Nonetheless, French prisoners continued to be housed at Bishop's Waltham until 1812.

16 *Frenchman's Bridge over one of the streams that join to form the River Hamble.*

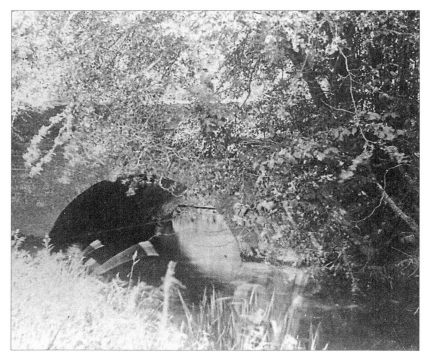

The Valley of the Mills

In an article that appeared in *Yachting Monthly* in 1912, and which will be mentioned further in a later chapter, a Commander C.E. Eldred RN described the estuary. The redoubtable Commander Eldred also took an interest in the river above Botley, recounting how 'fatal curiosity' caused him to take a bicycle and see whether the river there might be navigable by a small craft such as a light Canadian canoe. In this he was to be frustrated. Baffled in his attempt to follow the stream by railway embankments, barbed wire fences around strawberry fields and woods with a jungle of undergrowth, he eventually got to Durley Mill. 'Its weather boarding, hung with thick Virginia creeper, its red tiles coated in patches with green moss, the wooden hood of an old malt kiln, and the black punt tied up to a sloping garden full of bright flowers and apple trees, afforded colour enough for a dozen pictures …' The miller's wife having assured him that it would not be possible to come up to the mill from Botley, he was 'inclined to count this as the successful termination of my exploration'.

Eldred's conclusion was fitting, for the river above Botley was, in historical terms and in the still-born 1665 Navigation Act, the subject of the next chapter notwithstanding, always more about water power than navigation. A water mill might only produce two to five horse-power – but this was not insignificant in the economy of the Middle Ages, when sources of power were limited. And as Geoffrey Grigson reminds us, there is a whole vanished

17 *Botley Mill, pre-1960.*

folklore about mills and millers, 'those once prime figures of envy and blame in English country life' of whom it was said 'hair grows in the palm of an honest miller'. He mentions the clacking sound of the mill stones; if they were turning swiftly, they were saying: 'For prof-it, For prof-it, For prof-it'. If, though, they were turning more slowly, the message was sadder: 'No ... prof-it, No ... prof-it, No ... prof ... it', grumbled the stones. Such sounds would been frequently heard in this part of the valley, a distinct aural presence in the pre-industrial countryside. Although they were not all functioning at the same time, there were at least six mills on the stretch of river between Bishop's Waltham and Botley, and most have medieval origins.

One of the oldest is the mill at Botley. The present building dates from only the mid-18th century, but this is probably the site of one of the '2 mills rendering 20s' mentioned in Domesday Book. In 1536 it was let to a Thomas Everard at an annual rent of £4; the tenant was to repair the landings, cogs, runs, floatboards, trundle-heads and boxes. As we shall see, consideration was given to converting it into an iron-mill in the 17th century, but nothing came of this and it has remained a corn-mill throughout its history. Botley Mill ceased to function as such in the 1990s and is now being gradually converted into a museum of milling by its owners, the Appleby family. In the 20th century, it ceased to be driven by water power, but instead successively

by gas, oil and, from 1971, by mains electricity. The reason for this was that the abstraction of water at Bishop's Waltham for the public supply had reduced the river's flow. It was not a new problem. In a letter dated 3 February 1742, the Duke of Portland's steward, Clement Walcot, wrote to the Duke's attorney:

> Botley Miller claims for want of water and says Mrs Clewer who lives near two miles up the stream, has meadows which she waters from the main stream, he and two other millers says her watering the said meadows takes up one third part of the water which should come down to the mills, and is prejudice to all the mills. I went with Mr Fielder and called on Mrs Clewer who had the Bishops Woodward to go with us and see how it was, and found at the upper end of the meadows hatches locked down to prevent any one drawing them, which hatches stops the river from running down the antient course and so turn the water into back carriages to water the meadows, and what water goes off the meadows runs into the main river the lower end thereof, which is about a mile and a half before it comes to Botley Mill. Now between Botley Mill and the said meadows are two mills, one a corn mill, belonging to Durly Parish, which is but a little distance from the meadows and below that is a Paper Mill, which is above a mile from Botley Mill. I beg the favour of you to let me know whether at the time as all rivers and springs are so very low, Mrs Clewer can properly make use of the said water by turning it out of its course into her meadows to the prejudice of the said mills tho' it vents itself into the main river after it has left her meadows. Mr Clewer in his lifetime made use of the water as she now does but i am informed he never used to do it when water was so very low.

18 *Mill Hill, Botley, looking east, c.1908.*

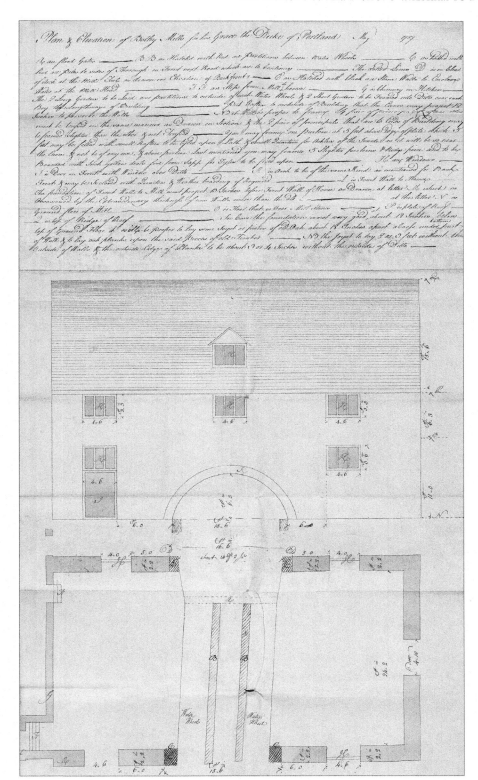

19 *Part of Botley Mill, in an 18th-century drawing/elevation.*

It is an interesting passage that is worth quoting in full. There does not appear any further mention of the Botley miller's complaint in the correspondence and probably it was resolved satisfactorily. It may have just been the combination of a particularly dry winter and the inexperience of Mrs Clewer in relation to such matters. Her husband – presumably the son of the Mr Clewer referred to – appears to have been incapacitated at this time; he died later the same year, probably from smallpox. It is particularly interesting for the evidence of water meadows on the Hamble and for the reference to the mills. The paper mill mentioned was Frog Mill, which stood on the eastern bank of the river, where it was reputed the paper for the *Morning Post* was manufactured. There is evidence of there being a paper mill there in the early part of the 17th century, and its history has been traced over three hundred years, but it does not seem to have been known as Frog Mill until the early 18th century. By 1862, the property is described as a 'Cottage and old paper Mill long since disused'. It seems that the mill buildings were largely pulled down at the end of the 19th century; the remaining part, to which there is no public access, owing its survival to use as a barn.

Moving upstream, the next mill is Durley Mill, which Commander Eldred found so picturesque, and which is on the western bank. It is probably one of the 'three mills rendering 17s. 6d.' mentioned in Domesday Book as belonging to the manor of Bishop's Waltham, the parish of Durley being historically part of Bishop's Waltham manor. There appears to be some confusion between Durley Mill and Frog Mill because a family called Frogge were tenants of the former in the 12th century. The 1693 Rental of Bishop's Waltham lists a separate mill called Paper Mills, but this is in the Curdridge tithing; Durley Mill is almost certainly the Frogmylle referred to in the Durley tithing. This fits with the topography. If the Froggmylle of the 1693 Rental had been Frog Mill, it would have been listed under the Curdridge tithing. Frogmylle is listed in the Pipe Rolls of the bishopric for 1301-2, when it was let for a year at 8s. Durley Mill continued to function until 1965, though by then it was oil-powered. Like the mill at Botley, it had been affected by the abstraction of water at Bishop's Waltham. A decade later it had been converted to a private house, though the single breastshot wheel was still in place, as were the sluices and eel traps, and the embanked mill stream still stood at its working level. Another survival was a bell, driven by a miniature waterwheel, which warned the miller when the water was too high in the leat.

Two other medieval water-mills have not survived: Caldekot, which was let for 10s. in 1301-2, and Mattokeford, which was let for 10s. A hundred years later both these mills had gone, perhaps a lingering economic effect of the Black Death. This had badly affected Hampshire in 1348-9, killing half its population and returning periodically afterwards. Caldecote had, it was

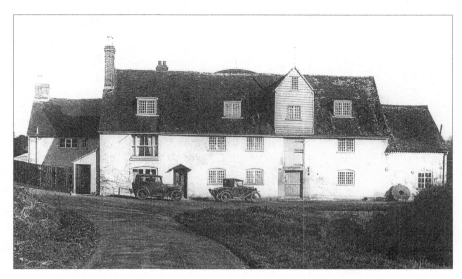

20 *Durley Mill, c.1908.*

recorded in the Winchester Pipe Roll for 1409-10, been 'completely pulled down and the vacant plot of the same is in the lord's hands'. The tenant, John Wodelok, had, it seems, simply thrown in the towel, abandoning it and refusing 'to hold it any longer'. A similar fate had befallen Mattokeford, which is known to have been in existence in the 13th century. The mill there had been 'completely pulled down and the vacant plot of the same is in the lord's hands and nothing can be found to distrain in the same', it was reported bleakly. It is reasonable to assume that Caldecote was at the present Calcot Farm, the lands of which were on the east bank of the river near the next bridge beyond Durley Mill, and which carries Calcot Lane over the Hamble. Mattokeford would have been close to Maddoxford Farm where Wangfield and Maddoxford Lanes cross the river by a bridge at or near the old fording place mentioned in the Anglo-Saxon charter.

The total of the receipts from the mills on the Bishop's Waltham manor in 1409-10 was £15 1s. 4d. Of this sum, 8s. was, of course, in respect of Frogmill, £1 6s. 8d. for an unidentified fulling mill at Curdridge, but the greatest proportion was the large sum of £13 6s. 8d. for the 'farm of the water-mill' at Bishop's Waltham. Its high return would indicate that it was the main manorial mill, but its exact location is not clear. It may be what is called 'the mill outside the gate', and one of the two other extant mill buildings above Durley: Abbey Mill. This large brick building on five floors has an 1862 date stone and can claim the unusual distinction of having been converted to a rolling mill in 1893 and then back to a stone mill in 1900. The name is something of a misnomer, because it was not associated with an abbey.

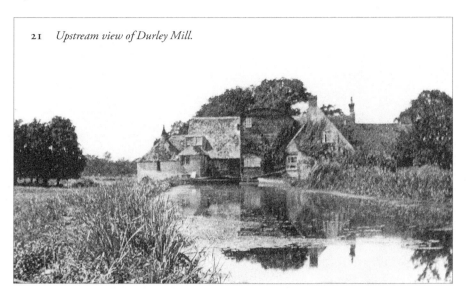

21 *Upstream view of Durley Mill.*

The final water-mill in the valley is not on the main river, but was driven by a pond spring-fed by The Moors. This is Waltham Chase Mill, which is probably the medieval East Mill and possibly another of the mills referred to in Domesday Book. The tenant, William Colnett, was ousted from the mill during the Civil Wars or their aftermath, but it was restored to him in 1661. Although dilapidated in the late 1780s, by 1799 it was referred to as valuable property, it being noted 'very few if any Mills ... do more business.' No doubt its location hard by the road from Bishop's Waltham to Waltham Chase, from which the fine 18th-century mill house can still be seen, was to its advantage, affording its customers easy access.

THE PHANTOM NAVIGATION

I truely treat that men may note and see
What blessings Navigable Rivers bee.

John Taylor,
John Taylor's Last Voyage, 1641

At a point a mile and a half above Botley, the Hamble is a seemingly nondescript feature marked by a line of alders at the bottom of a slope of neat pasture. A Bishopric lease of 1664, relating to Cookes Farm, to the south of Bishop's Waltham, reserved a right for the 'reverend father' to 'cutt dig or make or raise ... Draines Dykes Watercourses Trenches sewers channels and Receptacles

through any parte of the land meadow and pasture ground hereby demised' for 'the carriage or conveyance of goods and commodities by water in Boates or other vessells to and from the town of Bishopps Waltham and other adjacent places to and from the Sea at or neere Botley ...' The idea of hauling or poling barges along this quiet backwater, where I can stand mid-stream in the gravelly river-bed without the water topping my wellingtons, now seems slightly absurd. But the 17th century was the great age of river navigation – canals had their heyday slightly later – and, after a hiatus caused by the Civil Wars, the Commonwealth and the Protectorate, a spate of bills promoting the improvement of existing rivers became law.

On 2 March 1665, less than a year after the Cookes Farm lease had been granted, an Act for 'making small Rivers navigable' became law. The rivers included the Great Ouse in Bedfordshire, the Mole in Surrey and, in Hampshire, the Itchen, Test and Hamble. The Speaker of the House of Commons, in introducing the bill, advanced the usual arguments in favour of river navigation:

> It easeth the People of the great Charge of Land Carriages; preserves the Highways, which are daily worn out with Waggons carrying excessive Burdens; it breeds up a Nursery of Watermen, which, upon Occasion, will prove good Seamen; and with much Facility maintain Intercourse and Communion between Cities and Countries.

The Act conferred on certain named capitalists, or as it termed them undertakers, Sir Humphry Bennett, William Swann, Nicholas Ondart,

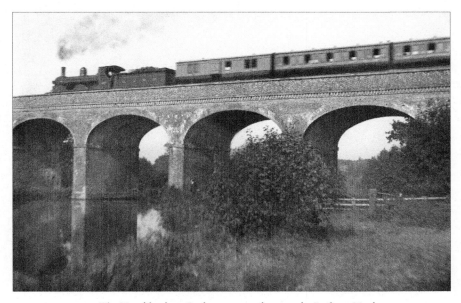

22 *The Hamble above Botley, c.1900, showing the Railway Viaduct.*

Robert Holmes, John Lloyd, John Lawson and William Holmes, the right to make these rivers passable by boats, barges and lighters by deepening the existing channels and digging new ones and by constructing locks and weirs. Roads or bridges could be replaced if they would hinder navigation and the undertakers could establish wharves for timber, wood, stone and coal and other materials. All the rivers were to be made navigable by 1 November 1671, five years later, failing which the Commissioners, essentially the regulators of the monopoly appointed from the ranks of the Justices of the Peace for the relevant county, could transfer the rights under the Act to other operators.

The Hamble was never made navigable above Botley and, unlike the Itchen, there is no evidence that the monopoly conferred by the Act was ever transferred to other entrepreneurs. There could have been various, perhaps cumulative, reasons for this. The Act specified that the charges for carriage of goods could not exceed a moiety (or half) of those payable for land carriage in 1663 and it may have been considered uneconomic to make such a short stretch of river navigable – it is no more than about three and a half miles in length from Botley to Bishop's Waltham and the distance by road was, if anything, a little less. It can be inferred from the reservation in the 1664 lease that the Bishop of Winchester supported the navigation, but it would be surprising if there was not strong resistance from the owners or occupiers of mills in the valley – the ones at Botley, Frogmill, Durley and Bishop's Waltham were operating at that time – and they would have had to be compensated. There may also have been opposition from those with interests in Botley, which may have been supplanted or diminished in its role of entrepôt at the upper reach of the navigable river if the scheme had gone ahead. Lastly, there may have been technical reasons that militated against the scheme being put into effect. Indeed, it is possible that the practicalities of making the Hamble navigable up to Bishop's Waltham, although a logical extension of the existing navigable river, never received any detailed evaluation before the passing of the 1665 Act – it was after all only one of a seeming rag-bag of southern rivers dealt with by the statute – and the careful reservation of rights in the 1664 lease, though repeated in subsequent leases until the 19th century, signifies nothing more than an episcopal pipe dream.

23 *George Morley, Bishop of Winchester.*

Part Two

An Arm of the Sea: Botley to Bursledon

Crossings

Although driving almost daily over the two bridges at Botley, I only really noticed them for the first time when I was taken in a small dinghy nearly up to the Hamble's tidal limit. The Botley Iron Bridge, which spans the Hamble proper, bears the legend, visible from the water, 'Rebuilt by the County 1853'. Another, brick-built bridge crosses the mill stream. Neither bridge appears to be of any great architectural distinction. The brick bridge has a low parapet that can be seen from the road. From the river one sees a massive wall of brick that is relieved only by a single segmental arch.

These bridges replaced earlier brick structures that were built about 1798. The *Universal British Directory of Trade, Commerce and Manufacture* for that year recorded that Botley had, 'but lately emerged from obscurity and contempt, by the erection of a large brick built bridge over the river; the fording of which was a terror to travellers, and caused many to prefer a long and circuitous road by Winchester, rather than trust themselves to its uncertain and fluctuating depth'. It would be tempting to infer from this that there was no bridge at Botley at this time, but there are 16th-century references to sums being payable by landowners – a shilling for each yardland, 6d. for each half-yardland and so on – for the repair of the Botley Bridge. A letter dated 1 November 1757 from Clement Walcot, the Duke of Portland's steward, to Robert Harley, the Duke's lawyer and *de facto* estate manager, clarifies the position. Walcot states that there are two timber-framed bridges 'over the River going into Botley', presumably referring to the fact that, as is still the case, two separate bridges were required; one for the main channel and one for the mill stream. Both were out of repair, he reported, and needed to be re-built with timber or stone. The Bishop of Winchester had agreed to pay 30 guineas towards the cost – the Hamble divided Botley from Bishop's Waltham, a Bishopric manor – and Walcot enquires whether the Duke will pay the same. An endorsement on the letter indicated that he was agreeable to this, and presumably the bridges

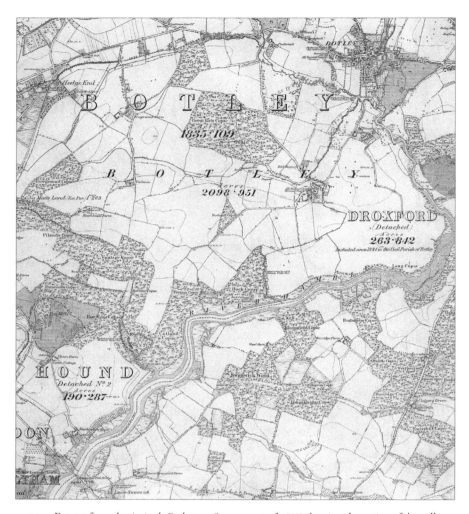

24 *Extract from the six-inch Ordnance Survey map of 1868 showing the section of the valley from Botley to Bursledon.*

were re-built, and these were the structures replaced by the new bridges constructed in the 1790s. Walcot makes a further remark in his letter that makes it clear why the erection of the new bridges in the 1790s was seen as such a significant event by the author of the entry in the 1798 trade directory. 'A new Bridge must be made otherwise there will be no passing,' he writes, 'this Bridge is not for carryages, only for Horses and foot people …' After the construction of the bridge in 1790s, carriages and carts could, probably for the first time, cross the river at this point without a long delay and avoiding the mud and water.

The village of Botley, or at least its economic centre, had shifted from its ancient site, around the old church and demesne farm (formerly called

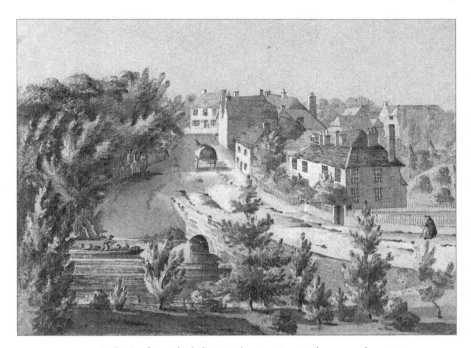

25 *Botley Bridge and a lighter on the river, in a 19th-century drawing.*

Botley Farm, but now called Manor Farm) in the medieval period, perhaps at about the time that John de Botelie, the Sheriff of Southampton, had received from Henry III the grant of a charter to hold a market, so as to provide a more suitable location for it. Another possible reason was the need to find a more convenient crossing place on the Hamble.

In any event, it is clear that the erection in the 1790s of a bridge that was capable of carrying wheeled transport was another significant event in Botley's history, transforming it from 'a place almost deserted' to 'a great thoroughfare from east to west'. Whether Botley was ever truly deserted must be a matter for conjecture; deserted by the right kind of traffic and traveller might be more accurate. By 1819, Botley is described as being 'a considerable village, with several handsome houses, and a very comfortable inn', but prior to the construction of the bridge and the improvement of the approach road at the end of the 18th century it may have had a more raffish air. People then attempting to cross over the Hamble could find themselves bottled up in the village for some time waiting for the tide to change, no doubt providing a captive trade for its hostelries and perhaps giving rise to the legend, at least, that it had 14 alehouses. The enforced stay in Botley might be risky for both a visitor's liberty as well as his purse, as it appears that it was a favoured place for the press gang. It is not perhaps coincidental that not only were 'protections' sought from the Duke of Portland in 1738

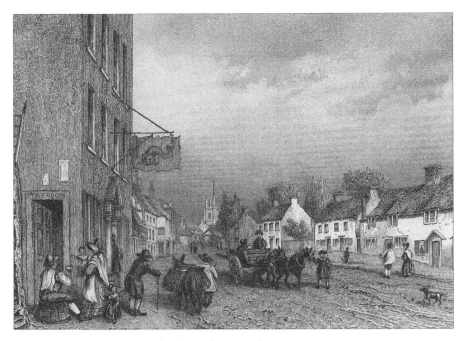

26 *Botley Square from a 19th-century engraving.*

for the crew of a vessel employed to bring stone from St Helens on the Isle of Wight for the repair of Botley Mill – a nobleman's protection afforded immunity against impressment. However, as recorded by Gilbert White in a letter written in 1778, a Selborne carter was also 'kid-napped in an ale-house at Botley by a press-gang, as he was refreshing himself in a journey to this place.' (At least he escaped the fate of the man who was murdered there by a soldier in 1628.)

Landscape historians will hopefully be able to provide a greater understanding of the relationship between the settlement at Botley to the crossing place, but we already know quite a lot about the crossing place of the Roman Road further down river, to the east of the old church and the Manor Farm. Route 421, part of the *Iter* VII, linking the Roman settlements at Chichester and Bitterne, crossed the Hamble at approximately this point, having followed an alignment that clips Pilands Copse, passes through Dockdell Copse and then runs to the south of the Manor Farm complex. It reached the bank of the Hamble opposite the Romano-British site on the promontory of land between the Shawfords Lake stream and Curbridge Creek. Investigations carried out in the early 1970s, during which trenches were dug across the alignment of the road on Manor and Marks Farms, revealed evidence of the road and, at the point where the road reaches the river, a 'causeway' of rough Purbeck limestone blocks. This latter feature

appeared to be about 13 feet in width and a yard in depth, though excavation of its base was prevented by water logging. The sea level was lower in the Romano-British period and this may have been an easier crossing place than would now appear. (Indeed, it may have been the rise in the sea level during the medieval period that prompted the northward migration of the Botley settlement and crossing place.)

At about the same time as the Roman road was being investigated, a limited examination of the Romano-British site revealed roof and flue tiles, mortar floors, tesserae and stone wall foundations, as well as a number of loose finds. The finds included pottery (New Forest and Oxford wares and fragments of Samian ware as well as pottery from Portchester and, more locally, Hallcourt Wood), glassware, bronze items and some coins. The pottery evidence indicates that the site, which consisted of either one building or several small ones, was used or occupied from the late first century A.D. to the late fourth century A.D.

The site of the junction of the 421 route with the road from Winchester is not known for certain, but the prevailing opinion is that it was at a site in the grounds of Coldharbour or Park Place, near Wickham. However, it has been suggested that the *vicus* (small settlement) that is believed to have existed at the junction of the two roads was not there but at Shedfield. This theory is based on the excavated evidence of Roman occupation at Shedfield House as well as the particular topography of the Hamble river and its tributaries. The argument runs that an alignment from the Romano-British site at Fairthorne Manor to Wickham would have required several additional

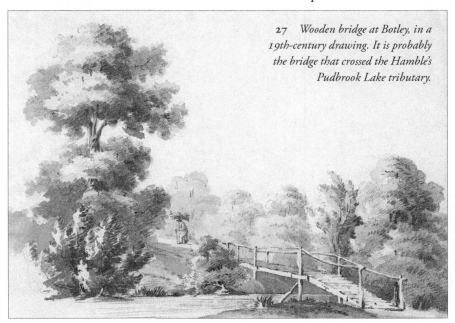

27 *Wooden bridge at Botley, in a 19th-century drawing. It is probably the bridge that crossed the Hamble's Pudbrook Lake tributary.*

crossings of Curbridge Creek unless the building of the road employed dog-legs around it. An alignment from the crossing point to Shedfield House, on the other hand, would pass midway between Shawfords Lake and Curbridge Creek without having to cross either of them.

'A River just about as wide as your Parlour!'

Travellers who entered the village of Botley from an easterly direction at the end of the 18th or early 19th centuries, along the roads from Bishop's Waltham and Titchfield and crossing the Hamble using the new bridge, would not have failed to notice an imposing, brick-built house on the west bank of the river. If they had lingered in the village for any time, they may, depending on the date of their visit, have heard mention of one or both of the men with whom it was associated: one a cunning fraudster; the other destined to be regarded as one of the leading political figures of his age.

The house had been built by the former, Robert Stares (1729-98), a merchant, farmer and for a time the Botley miller, who, if the legend of him is to be believed, became a man of substance in the area around Botley by

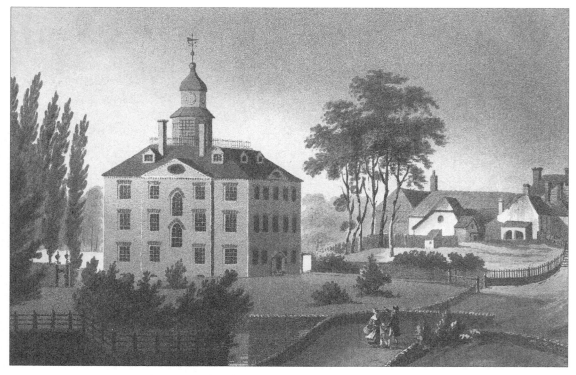

28 *Botley House and the bridge over the Hamble, in a 19th-century engraving.*

a mixture of cajolery, deceit and threatened or actual physical violence. His estate at Curdridge ultimately extended to over 500 acres 'in a ring fence', and he also had other property, including a half share in a 'Square sterned Carvel Built Sloop', which was presumably used for the shipment of flour. The local people were, it seems, initially taken in by Stares' 'fascinating mask of plain blunt integrity' and named him 'King Stares' on account of his position and wealth. When his financial position deteriorated, he attempted to mislead his trustees and creditors in their attempts to realise his assets. Finally, there was a dramatic confrontation, which would not have looked out of place in an 18th-century novel, when his trustees broke into his bedchamber and berated the prostrated Stares before searching drawers to find 'many writings and papers for which they had long been wanting' to complete sales of property. This final humiliation appears to have been too much for Stares. He died soon afterwards, an 'awful example of providential perdition following mortal infamy'.

The second person associated with the house was William Cobbett (1763-1835), the radical politician, journalist and pamphleteer, who had acquired it from Stares' estate in 1805. Cobbett quite literally came to occupy the same territory as Stares – a year later he purchased Fairthorn, the farm on which Stares had been born, and was to acquire other property once owned by him, apart from Botley House, and must have heard the stories of his rise and fall. According to his anonymous biographer, Stares' financial collapse was due to extravagance and by having overreached himself, and in a manner that strangely prefigured Cobbett's own. If this is correct, Stares' shade perhaps came to haunt Cobbett towards the end of his time at Botley when his own injudicious spending, as well as other factors, such as imprisonment on account of his writings, caused his own finances to unravel.

Cobbett had discovered Botley on a visit to Hampshire and the following year had purchased Botley House and moved there with his wife, Nancy, and their four children. Mary Russell Mitford (1787-1855), who was

29 *Portrait of William Cobbett.*

later to write *Our Village, Sketches of Rural Life, Character and Scenery* and to become a minor literary figure, visited Cobbett there as a young woman and later recalled the house as being 'large, high, massive, red, and square', a description corroborated by the advertisement that appeared in the *Hampshire Chronicle* just before Cobbett's purchase. This listed: 'Ground Floor, Dining and Drawing Rooms, Study, China Closet, two good Kitchens, and two Stair cases; on the first and second floors there are eight capital Bed-rooms ... a Turret and Clock at the Top of the House ...' Cobbett himself described it as being, 'about fifty feet long, forty wide, three clear storeys high, with a high roof and high chimneys.' According to Stares' biographer, the house had been built for his son-in-law, but was poorly constructed and was dubbed the 'lantern house' on account of its many windows. Along with the house, there were 4 acres of garden and meadow. The gardens ran down to the river and its proximity was undoubtedly part of the house's attraction, though it was a pigmy – 'a river just about as wide as your parlour!' he reported to William Windham, a government minister and political supporter – when compared with the ones he would have seen when on military service in Canada.

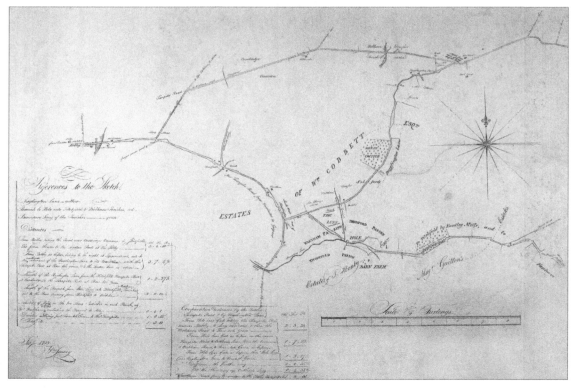

30 *Estates of William Cobbett as shown on a map dated February 1813. It shows the 'New Turnpike Road' that Cobbett rode along on his 1823 Rural Ride.*

Mitford, who stayed at Botley House about this time, describes Cobbett:

> … a tall, stout man, fair and sunburnt, with a bright smile, and an air compounded of the soldier and the farmer, to which his habit of wearing an eternal red waistcoat contributed not a little. He was, I think, the most athletic and vigorous man that I have ever known.

And of the hospitality that he provided, she says:

> There was not the slightest attempt at finery, or display, or gentility. They called it a farmhouse, and everything was in accordance with the largest idea of a great English yeoman of the old time. Everything was excellent, everything abundant – all served with the greatest nicety by trim waiting damsels.

It was perhaps after enjoying Cobbett's 'abundant' hospitality that, in about 1806, Lord Cochrane, the celebrated naval officer and a political ally, lay against a 'green bank' in the garden of Botley House with Cobbett's three-year-old son, James, asking him 'questions about the sky, and the river, the sun and the moon, in order to learn what were the notions, as to those objects, in the mind of a child', and found himself astonished by the boy's perspicacity.

For a time, during his first summer at Botley, before politics and farming came to crowd-out such activities, Cobbett turned fisherman and claimed to have caught, with the assistance of one of his sons, large quantities of young salmon, or peel, and trout, which were then coming up on the spring tide to spawn. John Wright, his assistant on the *Political Register*, was instructed to obtain and send to him a Flew or Trammel net, 5 feet deep and 15 yards long,

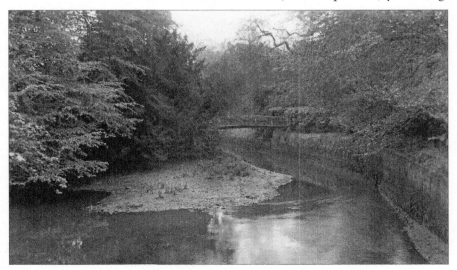

31 *Bridge over the Hamble linking Hill House and kitchen garden. This bridge linked the grounds of Botley Hill House to the site of Cobbett's by then demolished property.*

and subsequently a casting net. The fish were one to four pounds in weight and some were sent, through a political friend, Dr Parr of Eling, as a gift to Charles James Fox.

Cobbett has, unfortunately, left us with no detailed description of the Hamble, despite the years he lived on its banks, but he tells us much in his writings about the valley at the beginning of the 19th century. He always had a high regard for this 'clay and coppice' landscape of wood and water, farmland and heath, the outlines of which are revealed in the engraved lines of the first edition of the Ordnance Survey map. He writes of the 'immense woods and coppices' and the large tracts of common or heathland that, using a legal rather than descriptive term, he calls 'forest', and which are 'studded' with the cottages of labourers with their large gardens and sometimes small fields where cows, pigs, geese and bees could be kept, the kind of rural life that he described, and promoted in *Cottage Economy*. Despite reservations about the obstinacy of the labourers he employs on his farms, he admires them for their skill 'with the spade, the grub-axe, the hatchet, the saw, and the plough', and attributes this to the nature of the country, with its various forms of employment, season by season. (He is, though, irked by their superstitions, by their insistence that gardening and farming tasks should be carried out in accordance with the stars or appropriate tide, a perceived shortcoming that he attributes to the malign influence of the classical writers.) As well as the work in the fields, the

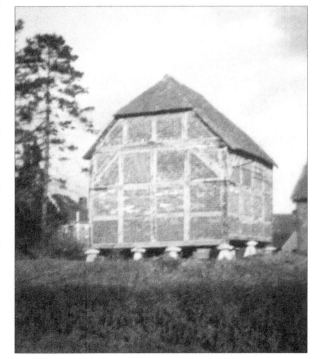

coppices provided winter and spring employment, as well as fuel. Coal, though, was also cheap, as it could be easily brought up the Hamble.

Botley ended badly for Cobbett, in bankruptcy and the loss of his house and the farmland he owned to the east of the Hamble, which were seized by the mortgagee. By then, Botley had taken on the character of Eden after the fall in the eyes of his daughter, Anne: 'It was an unfortunate choice of place for him at the first. Surrounded with Nabobs from India, and there being no small gentry except Army or Navy people. And there were Dock Yards and

32 *Granary of Fairthorne Grange, William Cobbett's Fairthorn Farm, 1946.*

Barrack Departments close by us, and whole hosts of people depending on Govt. favour.' It is unlikely that Cobbett ever saw it so bleakly. Not long after his bankruptcy, he was promising his children that he would 'earn as good a place as Botley back again'.

But he never did get such a place, and we have a sense of the pain that the loss of his Botley home and farms caused him in the account he gives of riding across Fairthorn Farm in 1823, on one of his *Rural Rides*. Mary Russell Mitford claimed that she was certain that the beauty of its riverside fields influenced Cobbett's decision to buy this farm, which had once belonged to the third Earl of Southampton, Shakespeare's patron. 'I had to ride', Cobbett writes, 'for something better than half a mile of my way, along between fields and coppices that were mine until they came into the hands of the mortgagee, and by the side of cottages of my own building. The only matter of much interest was the state of the inhabitants of those cottages'.

The tone is matter of fact, but one detects a repressed sadness and regret. It was not just the land, but what it represented, and was lost with it: domestic happiness, financial security and social prestige. And Cobbett does not altogether successfully mask his true feelings; he is simultaneously riding his horse and holding back an emotional floodtide.

The Waterway

The context may seem incongruous, but still it is instructive, when considering the historic function of the Hamble, from the beginning of its tidal stretch to its mouth, to stand before the 'Ditchley' Portrait of Elizabeth I in the National Portrait Gallery in London. Painted by Marcus Gheeraerts the Younger in about 1592, it shows the Virgin Queen towards the end of her life. Bejewelled and wearing a magnificent white dress, she stands on a map, derived from Saxton's, of which only England

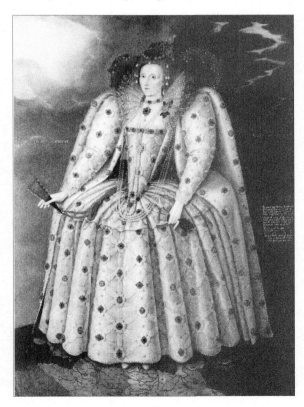

33 *The 'Ditchley' portrait of Elizabeth I by Marcus Gheeraerts The Younger. Oil on panel.*

and Wales can be seen. The toes of her feet are level with London and the
Thames Estuary, so that the Isle of Wight is at the bottom of the picture. The
map shows the principal towns and gives particular prominence to the rivers.
Of these, the Hamble can be seen clearly, with Bishop's Waltham a little inland
from the head of the estuary, as well as the Test, Itchen and Meon.

Almost contemporary with the 'Ditchley' portrait is Michael Drayton's
poem *Poly-olbion* in which the main topographical features of the country
– forests, mountains and rivers – are described. The Hamble is invoked as a
river-goddess:

> *Hamble helpeth out; a handsome proper Flood*
> *In courtesy well skill'd, and one that knew her good.*

The word *poly-olbion* (from Greek) means 'having many blessings'. *Poly-olbion*
is thus stating expressly what the 'Ditchley' portrait implies: that rivers are the
blessings of the realm. Rivers like the Hamble were, as we shall see, not only

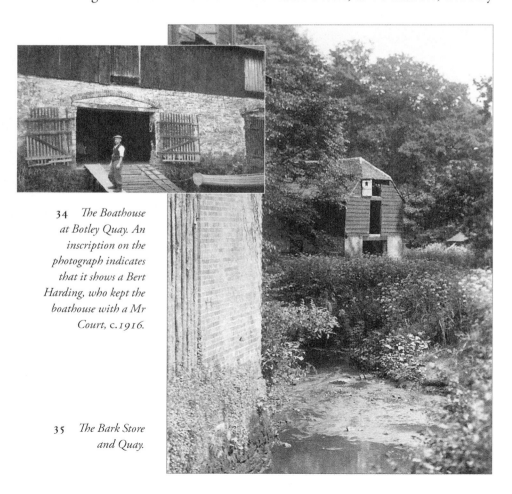

34 *The Boathouse
at Botley Quay. An
inscription on the
photograph indicates
that it shows a Bert
Harding, who kept the
boathouse with a Mr
Court, c.1916.*

35 *The Bark Store
and Quay.*

significant militarily, but, perhaps more importantly, were vital conduits for the conveyance of bulky goods and produce. For the Elizabethans, as much as for those in the centuries before and since – almost, in relative terms, up to our own time – the word 'waterway', with its connotations of a riverine road, best describes the way in which such rivers would have been perceived.

Less than half a mile from the site of Cobbett's house, there is a tangible reminder of the Hamble as a working river. Here at a place on the river that was known as Horsepool, where it is joined by its Pudbrook Lake tributary, one can still see stone quays and a surviving brick-built warehouse of the 1800s known as the Bark Store. The very idea of wharves and storehouses at this point on the river, where the river flows brown and turbid and is closed in by overhanging trees and bushes, seems slightly strange. It is easy to forget that we are already on the tidal river. Yet these wharves were, at least by the early 18th century (there is a reference to Horsepool Wharf in a 1735 document), an important local entrepôt from where wooden products were despatched and sea-coal delivered.

It is, in some ways, remarkable that the Bark Store should have survived into the present century. The river-trade was in terminal decline by the late 19th century. It was observed in the 1900s that the 'two small wharves which constitute Botley Harbour are now almost deserted.' A valedictory account written in 1903 recorded that:

> Forty or even thirty years ago … the banks of the river below Botley, now turned into fields, or put to other uses, were covered with logs of wood, and men were at work sawing timber, and making hoops and treenails, or wooden bolts for ships. This business had been decreasing all through the century, and many of the timber yards have long been fields; but a good deal survived, until ships, being entirely made of iron, could no longer be joined with wooden bolts; and iron hoops for the most part took the place of wooden ones for casks.

There is a photograph of a lighter bringing coal up river to Botley in 1914, but, as the 1903 account makes clear, the old lading places for timber had long been abandoned and the water-borne trade did not survive the First World War.

The river trade probably reached the peak of its importance at the end of the 18th and early 19th centuries when a developing industrial society, still burdened with a primitive road system and not yet advantaged by the coming of the railway, made greater use of rivers like the Hamble for the movement of goods. Still, it is surprising to see Botley as one of the Hampshire 'towns' – Basingstoke, Andover, Winchester and Beaulieu being the others – shown in *The Times Atlas of World History* as being connected with the river transport system.

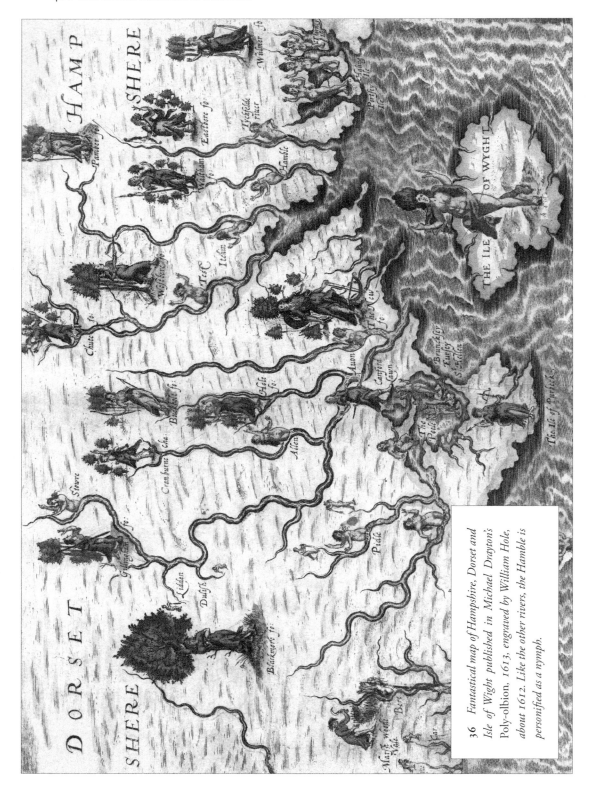

36 *Fantastical map of Hampshire, Dorset and Isle of Wight published in Michael Drayton's Poly-olbion, 1613, engraved by William Hole, about 1612. Like the other rivers, the Hamble is personified as a nymph.*

'A waterway', wrote the historian, Fernand Braudel, 'brought animation to the land all around. It is easy to imagine life as it must have been.' He evoked the appearance of the 'broad and now empty river Saône' in France, picturing 'the busy scenes of the past, with boats carrying wine and "goods from Lyons", corn, hay and oats downstream'. Such scenes were universal and, though on a smaller scale, and with different items being conveyed, we can construct a similar picture of water-borne trade on the Hamble in the 18th and 19th centuries from maps, trade directories and archival materials in the Hampshire Record Office, including the estate records of the Dukes of Portland, one of the valley's great landowners, and the Waller Papers. The latter are of particular interest. They comprise the legal and business records of William Waller of Bursledon, a mariner and ship-owner engaged in the coastal trade. They not only include details of the cargoes carried on such vessels as his 63-ton sloop *Diana*, and the final destinations of such cargoes, but also record the journey they took from field or coppice to the waterside.

The entry for Bursledon in a 1798 trade directory records: 'In this port, the vessels employed in the flour, timber, and hoop, trade of Botley are generally stationed, and receive their cargoes, which are conveyed to them in lighters from the mills etc.' The commodities that are referred to were the most important ones moved by water at that time. The hoop trade was of some significance locally, and had been in existence since at least the 17th century. Hoops were the thin strips of coppice wood used to bind the slack barrels in which all manner of dry goods, including flour, gunpowder and fish, were transported. They were made in various lengths from 1 foot to 18 feet. Many of the hoops were sent to the Channel Islands and southern Ireland – places with which Southampton maintained trading contact during the Napoleonic Wars – and the West Country and even the West Indies. Cobbett noted in his silvicultural handbook, *Woodlands*, that ash coppice wood 'assists to supply the Irish and West Indians with hoops for their pork barrels and sugar hogsheads', and in 1807 observed that the 'dozen or so men, who make in the coppice-cutting season, hoops for the West Indies, there to be used in making sugar and rum casks' were all Botley had in the way of foreign trade. (There had been a revival in trade between Southampton and the West Indian islands in the late 18th century.) He seems not to have considered as 'foreign' the trade with southern Ireland that was being carried on during the years he spent at Botley. Some forty years earlier, in 1766, the Duke of Portland's woodward, Robert Fielder, informed the Duke's lawyer that 'the under Cops wood of rice and Poles in this part is made into hoops and carried into the West part of England for Cyder and Fish Casts'. This trade continued into the 19th century and Waller sent consignments of hoops to St Mawes, Fowey, Penryn and Mevagissey on the south Cornish

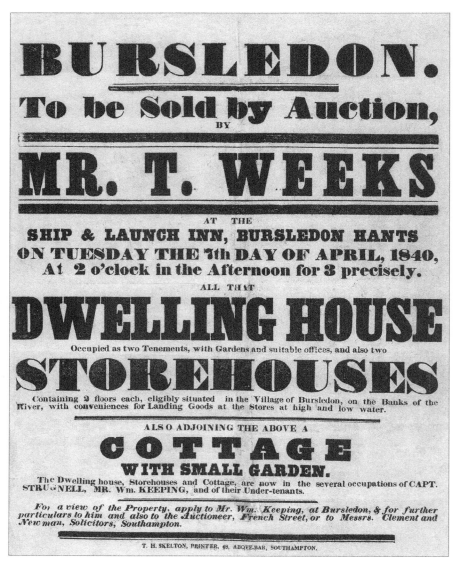

37 *An 1840 sale advertisement for House and Storehouse at Bursledon. It points out that at the warehouse goods can be landed at high and low tide.*

coast where they were almost certainly used in the making of slack barrels for the storage and conveyance of pilchards and other fish.

As we shall see, the valley woodlands were managed chiefly with the requirements of the hoop-makers in mind, but other woodland products were also traded. Waller despatched oak planks and treenails to Cornwall as well as meeting more local requirements by supplying bavins (small faggots) for firing to Mr Hobbs, the Bursledon baker, and to the owners of brick kilns, of which there were several within a short distance of the river.

As the 1798 trade directory makes clear, the Hamble was also used to bring corn up to Botley and, following milling, to transport the flour. Milling was an important activity in southern Hampshire at this time, with grain being brought in from surrounding areas to be milled. Robert Stares, the notorious Botley miller, whom we have already encountered, was reputed to have driven a hard bargain at Chichester and the other Sussex markets with which he dealt, suggesting that corn was brought a not inconsiderable distance to be milled at Botley, and he was not just serving the local market. Coal from the Tyne and Wear coalfield could also be transported cheaply up the Hamble from Southampton. Indeed, Cobbett surprisingly claimed in 1816 that it was cheaper to purchase coal than wood in the Botley district: 'A wood-fire, though in our woody-country, is an expensive luxury. In better times I used to burn my own wood: the hardness of the times has induced me to *buy coals*!'

Waller's account and memorandum books for the first couple of decades of the 19th century throw much light on the manner in which underwood products were being transhipped, before being carried off to more distant markets. In 1818, for example, he purchased from a Mr Carpenter of Colden Common, to the north-west of Botley, 11,800 straight hoops 7½ feet in length, 16,600 straight hoops of 5½ feet in length, 20,500 of 4½ feet as well

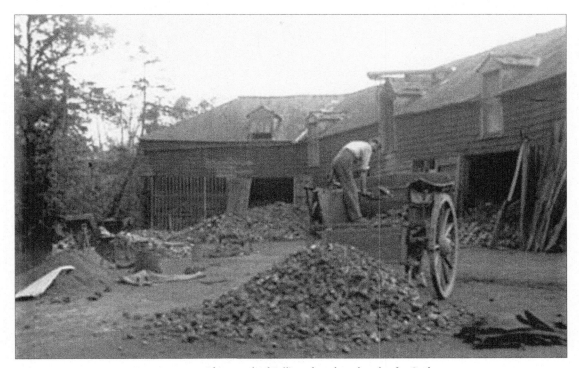

38 *Photograph of Bell's coal yard on the wharf at Botley.*

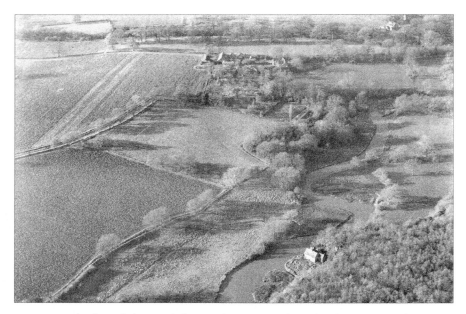

39 *Low-level aerial photograph showing the river at Pinkmead. It shows Pinkmead Cottage and, on the right-hand side of the photgraph, the site of the 19th-century timber yard.*

as 25 bundles of straight hoops of 9 feet. On other occasions he would pay for the coppice goods to be made up. In January 1819, for example, a James Mondy made to Waller's order 5,325 kiln bavins, 1,575 broom handles, 1,425 round faggots and 375 Bunt bavins in Mr Gater's Coppice at West End.

These woodland products purchased by Waller were drawn from the Hamble valley and surrounding parts, usually from the area to the west of the river – West End, Pilands Coppice at Bursledon and Mr Emery's coppice on Heathhouse Farm in Botley Parish. They were brought to the waterside by hired cart – 'Mr Gaters Waggon' and 'Mr Salt's Waggon' are mentioned – to one of the quays or landing places on the river. As well as the one at Botley, there was a stone quay and its associated timber yard a half mile further down at Pinkmead. The latter appears to be a place of some historical importance as it was probably the place, then called Pynkehaven, where in 1438 12 loads and a pipe of stone from Caen in Normandy and a quantity of stone from Beer in East Devon were unloaded and transferred to carts for the onward journey to Bishop's Waltham to be used in the construction of the Bishop's Palace there.* There was another lading place and timber yard at Curbridge, at the tidal limit of the creek that flows into the main river from the east. This was, at least during the time that

* Pynkehaven or Pinkmead may have been the place referred to generally as Botley in the 14th and 15th centuries as being the centre for the importation of blue slates from Devon and Cornwall. These slates were purchased by Winchester College and St John's Hospital, as well as for work to Wolvesey Palace in Winchester.

it was owned by the Dukes of Portland, earmarked as a 'free wharfing place', where timber and underwood purchased from the estate woodlands could be temporarily deposited without charge. There were other hards – principally to serve the timber and underwood trades – at Dock Creek on Botley Farm, on Harmsworth, Burridge and Swanwick Farms and at Eyersdown. There were also hards and quays to serve the brickworks at Hoe Moor and latterly Swanwick.

At these places, now often reduced to little more than the withered stumps of the upright posts, underwood, bricks and other items were transferred to lighters, the small barges that plied the river between Botley and the pool at Bursledon, where their cargoes were transferred to larger vessels. These hards would have been particularly busy during the winter months, the busiest time of the year for timber and coppice trades. At Pinkmead, there was even a public house, the *Blue Anchor*, the existence of which is only really explicable in terms of its use by those engaged in the river trade. Even now its site is remote from any road or settlement. I recall visiting the house six or seven years' ago, not long before it was demolished. It had long since been used as a private residence, but what would have been the parlour of the public house contained a massive beam with initials carved into it. It was not difficult to recover, in the mind's eye, the scene there 200 years or so before: the throng of bargees and timber workers; the pall of pipe smoke; the voices, sometimes raised; the talk mixing local gossip with the price of underwood.

A public house was no doubt a necessary feature. The Solent's peculiar tidal regime, with its extended period of rising or standing water level – the

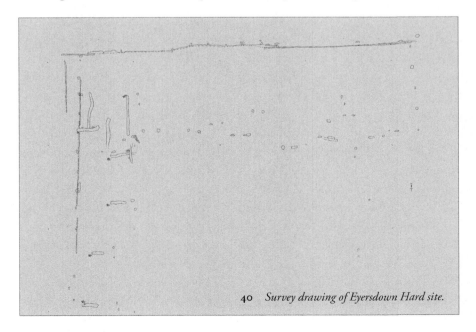

40 *Survey drawing of Eyersdown Hard site.*

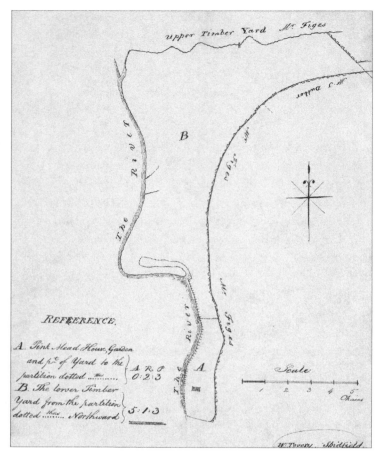

41 *Plan of timber yard at Pinkmead, c.1800. It also shows the location (just below the letter 'A') of the* Blue Anchor *public house.*

'Young Flood Stand' – was no doubt of assistance in loading and unloading cargoes. However, it was probably uncommon for a lighter to be loaded, unloaded, and away on the same tide. An Albert Clarke, who worked at Botley mill and was one of the last generation to have any connection with the working life of the upper part of the river, recalled in the 1960s how on one occasion all work stopped at the mill while all the men helped to unload a coal barge, so it could be got away quickly before the tide turned. Normally there would be a few hours of drinking time before the lighter set off back to Bursledon. Clarke also recalled the difficulties encountered by the lightermen in negotiating the bridge at Botley. The lack of headroom meant that the men had to lie on their backs on top of the piled sacks of grain in the lighter and use their hands and feet to make progress under the arch.

The Waller Papers refer to the individuals who operated lighters on the Hamble – Mr Wilshire's lighter and John Mears' lighter – and it is possible, given that it was an Augustus Mears who has been identified in a 1914 photograph, that the operation of a lighter, like other trades, involved both

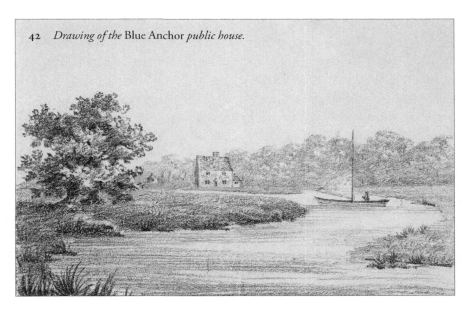

42 *Drawing of the* Blue Anchor *public house.*

inherited skills and equipment. In the 18th century, the cost of lighterage appears to have been a common matter for negotiation between buyers and sellers of coppice-wood products. If the demand for hoops was high, the shipper would bear the cost of lighterage; if demand was low, the copse merchant would bring them to the 'vessels side', i.e. they would have to bear the cost of water transportation to Bursledon. While the small underwood 'stuff' was barged, some at least of the large timber was simply towed. There

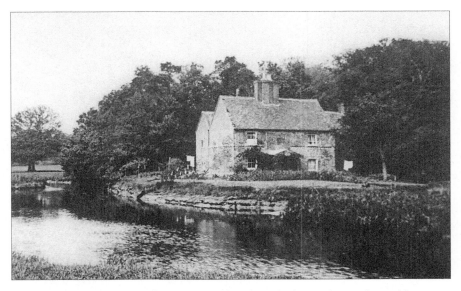

43 *Pinkmead Cottages and River, near Botley. This is the former* Blue Anchor *public house, by then a private residence.*

are 18th-century references to the 'rafting' of timber on the Hamble, and at
the beginning of the last century it was recalled how people using boats on
the river had to avoid pieces of tied-together timber being floated down.

One suspects that the pattern of the river trade changed little over
the centuries. Sometimes, though, there were more unusual visitors. It
is known from Southampton's municipal records that in the autumn of
1493, Venetian merchant vessels – part of the fleet of 'Flanders Galleys'
that visited England and Flanders annually between 1314 and 1532 –
called at Southampton. These vessels' cargoes of spices, precious stones,
silks and velvets, armour and weapons were exchanged for wool, cloth and
tin and pewter items, as well as timber from along the Hamble valley and
other places that could easily be reached by water from Southampton. In
September and October of that year ash trees at Botley and Droxford were
selected, felled and taken to the riverside, before being taken by water to
Southampton. The trees were acquired in batches – 10 from one landowner,
35 from another and so on – and were presumably carefully chosen on
account of their size or some other quality of the timber. In all 125 trees
were purchased and Roger Long was employed 'for hym and his bote to
feche home part of thasshis from Botliegh', at the end of October. Some of
the trees are left behind to be collected by the barkeroll of the Galley *Valier*
in January. A payment is made to 'markes of botley for licence to cary
ouer his grounde all the asshys and tymber there brought for the next and
fairest waye'. (This is almost certainly a reference to the land now called
Marks Farm, which lies between the Manor Farm at Botley and the river.)

44 *Coal lighter coming up to Botley Mill in June 1914.*

Disputes about the damage caused to crops by the carriage of timber recur from time to time across the centuries, but such problems were presumably avoided on this occasion.

It is possible that the Venetian galleymen purchased timber in the valley in other years, but the usual long-distance market for the timber and underwood was it seems the West of England, as in later centuries. As early as the 1570s, there are complaints being made about the 'greate decay of woode' due to the 'excessive cariadge away of the same by shippes and barcks out of the west conterie & other places w[hi]ch continnuallie doo lade & carie o[u]r saide provission of woode from the haven of hamble & biesseldon …' And a century later there are references in the Port Books for the Cornish coastal town of Looe to vessels from Hamble and Bursledon bringing there cargoes of timber, hoops, planks and other wooden products. The West of England was still the main trading destination in the 18th and 19th centuries and there is a tangible reminder of that trade in the claim that some of the stone used for the footings of some of the houses in Old Bursledon was brought back from the West Country as ballast. As will be seen in the next chapter, producers of timber and underwood geared themselves to meet the demands of the West of England and other distant markets. By the end of the 19th century, as Alfred Clarke's recollections make clear, the Hamble was, with the growth of the empire and an increase in overseas trade, connected to more distant markets. Large sailing vessels from Russia, India and Australia brought corn to the pool at Bursledon where it was transferred to lighters to be taken up to Botley for milling.

WOODLANDS

The work in the woods occupies the whole of the winter; the felling of the oak timber every month of May, is equal to a harvest in point of profit to the labourer, and even surpasses the harvest as it furnishes him with an abundance of fuel, and employs every woman and child able to work.

William Cobbett, *Political Register*, August 1816

William Cobbett, owner and manager of extensive woodland on his farms in the Botley district, who had his own timber yard, now just a meadow, on the north bank of Curdridge Creek, knew well the woodland economy of the Hamble valley in the early 1800s. The pattern of the woodland year that he identifies can be fleshed out in abundant estate records of that and previous centuries. Until they began to decline in importance during the late 19th century, the woodlands in the parishes bordering the river were greatly valued for their timber and underwood.

Their proximity to the navigable river was an added boon, allowing the timber and coppice goods to be transported easily and cheaply to various, sometimes distant, markets.

These woodlands, ranging in size from an acre or 2 to over 40 or 50, were managed as 'coppice-with-standards', what has been termed the classical system of woodmanship that produced both timber (the standards) and underwood. The main uses of timber, as a 1608 document makes clear, were in 'Building and Shipping'. The erection and repair of buildings and bridges required a constant supply of timber and, to the extent that it was used in wattle and daub, underwood.* In the winter of 1742, for example, the Duke of Portland's woodward is asked by the Botley churchwardens for timber to make shingles to repair the tower of the church. And in the 18th century, there was, as we shall see, great demand for timber to build and repair ships, not just from the naval dockyard at Portsmouth but also from private shipbuilding yards on the Hamble contracted by the government to build for the navy. This was not a new phenomenon. In 1295, when various seaports were required to build galleys for the Crown to be used to combat Philip IV's squadron of fighting galleys based at Rouen, the timber for the Southampton galley came from Botley and Wickham, the accounts relating to its construction recording that the cost of carriage by water of 65 tree-trunks from Botley to Southampton was 7s. 0d.

The principal timber trees to be found in the valley were oak, which according to Cobbett grew well in its 'stiff' clay soil and which still dominate the landscape, and ash, the former at least in the middle of the 18th century the more valuable of the two. It was no doubt with the needs of shipwrights in mind that Robert Fielder, the Duke's woodward, bemoaned the shortage of elm timber on 'his graces mannors' – water resistant elm was used in the construction of ships' keels and for underwater planking, though he did identify for felling two large elms on Fairthorn Farm. Lime trees also sometimes feature in timber-sales accounts.

By the late 17th century, timber and underwood were each attracting specialist buyers, and this sometimes gave rise to conflict. In 1688 a complaint is made to the Navy Commissioners Board that the best trees in Titchfield Park were being 'docked for buckets'. This is almost certainly a reference to the activities of hoop-makers, who, as has already been noted, were the main customers for underwood from the woods along the Hamble. By this time, coppice rotations are being directly linked to their requirements in terms of the size of the poles of underwood. 'The coppices

* One can still see an unplastered panel of wattle-and-daub, protected by glass, in a shop in Botley Square that was once an alehouse called the Catherine Wheel and in the more recent past was the Botley bakers; a nice reminder that the local woods did not just produce bavins for the bakers' ovens.

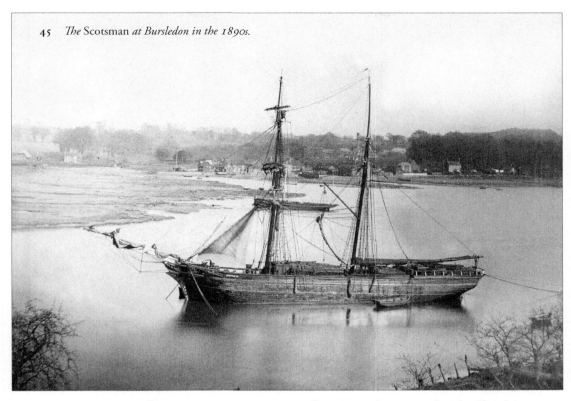

45 *The* Scotsman *at Bursledon in the 1890s.*

are generally cut twice in 24 years, often in 22,' wrote a local official in
1735, in response to a query from the Duke of Portland's lawyer, '& thats
always best for Hoops'. And the local view was that hazel was the best sort
of underwood to promote. Indeed, such was the dominance of the hoop
trade as a customer for underwood that any fall in the price of underwood
is more often than not attributed to the low price of hoops. Explaining
in 1758 why the underwood in the two coppices on Hall Court Farm
– Ferney Close and Great Wood – had sold for much less than 11 years
before, Robert Fielder observed that, whereas in 1747 hogshead and barrel
hoops sold for upwards of 44s. and 30s. a load respectively, they now sold
for 30s. and 20s. a load respectively. By at least the early 19th century,
hoops were being produced on workshop lines, with the sturdier truss
hoops being made indoors, steaming and rudimentary machinery being
used to bend them.

Another important user of underwood during the 18th century was
the local iron master. John Gringo's ironworks at Funtley, Bursledon and
Wickham will be discussed in a later chapter. It is sufficient to note here
that he would have required large quantities of underwood for his furnaces.
And his unexpected appearance at the annual auction of underwood in
November 1741 caused the copse buyers to 'advance upon one another'. The

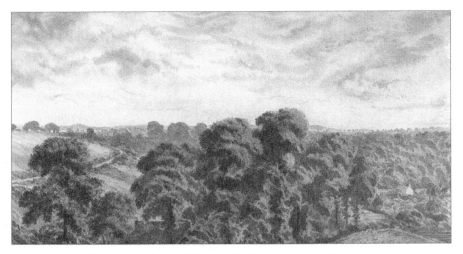

46 *View of the valley from Vicarage Garden, Bursledon, 1887, watercolour.*

following November Fielder reported, '… times never was so bad in selling coppices (as it is now) and the reason is the persons that bought the last year, have now all their Colefire wood, now standing in the coppices, unsold, and there is nobody but Mr Gringo to buy, he will have it at his own price, for I deign that he does not give them 10s. a coalfire* for it and they have most of their hoops by them unsold'. These comments make it clear that Gringo was either buying standing underwood direct from the woodland owner or purchasing felled underwood from a middleman. A letter that Gringo wrote to Thomas Puckeridge of the Southwick Estate in 1772 is of interest in showing how he dealt with the underwood he purchased. He requested additional time to 'coal' the trees he had purchased on account of the poor state of the roads – the same dispensation he had been granted by the Duke of Portland's officials – and stressed that he did no damage to the coppices: 'my men make no use but with wheelbarrows in getting the wood together'. This seems to suggest that the charcoal was made on the spot, with only wheelbarrows being needed to move it to the nearest road.

In the winter of 1756/7, and contrary to usual practice, certain coppices on the Portland Estate were coppiced by men directly employed by the woodward and steward. The accounts that survive give a valuable insight into the nature of the underwood products that could be garnered from each individual coppice. Swan Coppice, a 4-acre wood that then lay just to the west of Botley, but long since lost to the expanded village, produced 1,950 bavins, 2,380 kiln bavins, 60 dozen hogshead hoops and 40 dozen barrel hoops, 1,200 smart hoop rods and 850 broom handles. Some cordwood is allowed gratis to the purchaser of the bavins.

* A 'coalfire' was it seems 33′ of cordwood, 4′ 6″ high and 2′ 8″ in breadth.

The purchaser of the bavins was Henry Spencer, owner of the brickworks at Hoe Moor at Bursledon, one of several brick kilns in the valley. In 1754, Robert Fielder requests on behalf of his brother a 'two years cutt' for Ridge Coppice 'for it lyes in such a wet dirty place and there is a great deal of under coppice wood cut this year on Mr Delmes' manor which lyes a great deal nearer the Brick-kilns than Ridge Coppice does so he is afraid he shall not sell the Bavins but they must lye in the coppice and rott which will be a great disadvantage to him …'

The poor state of the roads is a frequent source of complaint, and helps explain why the presence of the navigable river was a great boon to the woodland industries. As early as 1609, a John Watering is being asked to acknowledge that his use of the way through Catland Coppice on Botley Farm to carry timber to the waterside from his land known as Collpits 'hath been used by him and his ancestors upon suffereance and by the lycence of the ffarmers of Botley and not of right as Comon or usual way'. A 1740 survey of the Duke of Portland's woodlands not only assesses the quality of the timber and underwood and the 'Kindness' of the ground for growing trees, but also the proximity of each wood to the Hamble. Trullmill Coppice on Fairthorn Farm, for example, has 'some good Large Trees fit to fell, very few young Trees. Some good underwood', and is not far from the waterside. The same document records that Ridge Coppice, where James Fielder sought extra time to cut and remove underwood, had some good large trees fit to fell and the land was 'kind' for timber and underwood, but it was one and a half miles from the river, and it seems that removal of timber even a relatively short distance over 'dirty' unmade roads or tracks was problematic for the copse or timber merchant. It was to help with the prompt removal of timber and underwood that the 'the old Hard against Swanwick Farm against Botley River' was repaired in 1764. The farmer there had complained that he was 'a great Sufferer' from the underwood and timber being left on his land and his receiving no compensation for this. In April 1747, John Souter, the tenant of Botley Farm, had complained about damage done to his corn in his fields called Copshot and Rowlands Flood as a result of the carriage of timber across them. Interestingly, the Duke of Portland's lawyer suggested that future tenants of Botley Farm should not be allowed to plough too much land 'considering its soile & Situacon in ye Dirt and the midst of Woodlands when great part of ye Corn must be eaten by the Birds of all sorts'.

It did not help, of course, that traditionally coppices were cut in winter, when not only was there less farm work being done and no leaves on the trees,

. Peter Delmé had purchased half of what had been the Earl of Southampton's estate to the east of the Hamble – the Dukes of Portland owned the other half – and Delmé was, therefore, a rival seller of underwood.

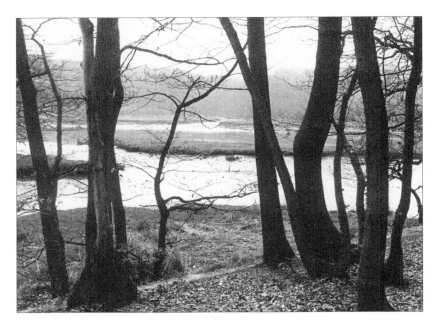

47 *View of Hamble from Fosters Coppice. Late 20th-century photograph.*

but the roads would have been at their worst. The underwood year began with the autumn sales. Surviving among the Portland estate papers are a number of formal agreements with buyers from the 1750s that would have been signed after the auctions, and which set out the terms of the sale. One for Maids Garden Coppice on Swanwick Farm in 1752 records the common-form conditions: the purchaser, John Tribbeck of Swanwick, is to pay half of the total price of £7 11s. on signing; the balance on Midsummer Day (24 June); he is to preserve any 'Timber or Timber trees Stammers young ayres or Saplins' on pain of a fine of £50 for each timber tree cut down and 5s. for each stammer, heir or sapling.*

Timber was also, in the main, felled during the winter, when the leaves were off and the sap down. The only exception was oak, valued as much for its bark as its timber. Bark was used in the tanning of leather, an important local industry from the 1700s. There were tanyards at Bishop's Waltham, where it was one of the town's principal trades along with malting, and Botley, where a Tanhouse Lane still runs south from Hedge End towards the main mass of woodland east of the river. The bark for tanning was only taken once the sap had risen, the 'stripping season', as Cobbett noted, occupying the whole month of May. The bark trade fell into decline in the late 19th century, but even in the 1900s people could still recall how the ghostly whiteness of the stripped branches and trunk of a felled oak tree would sometimes startle horses.

* The fossil word 'heir' survives in the minor place name of Eyers Down Farm, just to the north of Burridge.

48 *Tree fellers on the water side. Charcoal drawing, c.1830. It may show the timber yard at Pinkmead.*

Now that the woodlands of the Hamble valley are valued more for their wildlife than their monetary value, it is easy to overlook their past economic importance. Some simple figures can remind us of this. In 1787, when it was acquired by the nabob, William Hornby, the 166-acre Fairthorn Farm was let for £100 a year. The woods were 'in hand', that is, they were as usual excluded from any tenancy of the farmland and the landowner retained directly the income from them. The underwood from one coppice on the farm, Landing Place at Curbridge, was sold in 1758 for £61 19s. Admittedly this was a one-off payment received every nine or 10 years or so, but there was in addition a periodic return on the sale of timber, and it does demonstrate the value of woodland relative to farmland. Sales of timber from the same coppice during the 10 years from 1759 produced well over £150. Small wonder, then, that the Reverend Richard Baker, the Botley rector and a notoriously uncompromising collector of tithes, pursued an expensive court action against a James Warner over his claim to a tithe on the underwood cut in several coppices on the farm within Botley parish in the years 1803 to 1806. Baker eventually lost the case, the court deciding that the rector held Parson's Coppice in lieu of a right to a tithe on underwood. But he may still have felt that a right to a tenth of all underwood cut each year in Botley parish – the action against Warner was effectively a test case – had been a prize worth pursuing despite the vagaries of litigation. And it is a measure of the importance of woodland that landowners were seeking to establish plantations in the mid-18th century: Dore Hill, Marles and Kitland on Botley Farm in the 1750s, and Calcot Plantation at Breeches Hill at Durley in the 1760s.

Not surprisingly, the various wars that Britain fought in the 18th and 19th centuries created a demand for timber from a heavily wooded area directly linked by water to the naval dockyard at Portsmouth. The decision by the Navy Board to award contracts to build warships in private yards, to the so-called 'country builders', was much welcomed by timber merchants and landowners. Shipbuilding on the Hamble is the subject of a later chapter and here it is sufficient to note that in the 1740s, the period straddled by the 1739-48 war, 12 ships were built on the river. During those years, timber on the Duke of Portland's estate was not only sold to the principal timber merchants operating in the area, John Clewer of Calcot and Thomas Colchester of Bursledon, but also direct to the yards. Shipbuilders Philemon Ewer and Richard Heather purchased lime trees growing on the Duke's land in the Forest of Bere. The boom did not last long. Inevitably, too much timber was felled and supply came to exceed demand. In April 1748, Colchester is indicating that he will not pay more than £3 a load – previously, in 1745, he had paid £3 5s. a load for the bulk of the oak timber (705 trees) he had bought. By September 1748, Robert Fielder is writing, somewhat disconsolately, that 'there is such a great quantity of timber now cut and at the Waterside unsold by the timber Merchants – and timber is a great Drugg here – so that I hope in a year or two when the old Stock is gone it will Sell better'. There appears to have been another mini-boom during the Seven Years' War (1756-63). Although there were only two small ships actually built on the Hamble during that conflict, the price of a load of timber rose to £3 15s. a load. The estate records peter out after that, but no doubt there was a similar situation in the 1780s, the decade that straddled the American War of Independence. During this decade John Clewer and others, including Robert Stares, had contracts to supply timber to Portsmouth Dockyard and the great George Parsons and others were building ships for the Navy on the Hamble, and during the Napoleonic Wars, when again there was naval shipbuilding on the river.

The 18th century seems, in retrospect, to have been a golden age for the Hamble valley woodlands. In less than a century, the situation was to change dramatically. A fall in demand for timber for shipbuilding and bark for tanning after the 1850s, coupled with a boom in farming, meant that, whereas 100 years before new plantations were being established, landowners now began to destroy coppices. By the time of publication of the six-inch Ordnance Survey map in the 1860s a number of the woodlands recorded, year on year, in the Portland estate papers, have gone. Coppice Shot Coppice (13 acres) on Botley Farm appears to have been grubbed out in 1842, Little Hatts Coppice in the winter of 1846 and 1847. Great Hatts Coppice, too, had been removed by the end of the 19th century, probably by James Warner of Steeple Court, the son of the man who had fought the tithe case with Richard Baker and one of a new generation of

TIMBER at DURLEY,
HANTS.

FOR

Sale by Auction

By Mr. LIMPUS,

On WEDNESDAY, APRIL 22, 1807,

At Three o'Clock in the Afternoon,

At the CROWN INN, BISHOPS-WALTHAM,

(Agreeably to Conditions which will be then and there produced)

Three Hundred and Sixty

Oak Timber Trees,

WITH THEIR

LOPS, TOPS, & BARK,

In TWO LOTS, viz.

LOT 1.—270 TREES, standing and growing on DURLEY MANOR FARM.

LOT 2.— 90 TREES, standing and growing on LONGLANDS, and the POUND FARM, in the Parishes of DURLEY and UPHAM.

For Particulars, and for viewing the Timber, apply to the AUCTIONEER, BISHOPS-WALTHAM.

SKELTON, Printer, Southampton.

49 *Advertisement offering timber for sale at Durley.*

improving landowners. The underwood industry was by this time also suffering from foreign competition and thereby losing its traditional markets for hoops, such as the Cornish fishing industry. It was noted in *The Victoria County History* in 1908, in relation to Botley, that 'the hoop-making trade, which employed a number of hands, has disappeared …' The comment was premature – there was still a hoop-maker, Charles King, operating there in 1920 – but only a little; by then the trade was in its death throes.

It did not take long for the timber and underwood trades, their particular patterns of working life and presence in the landscape, to fade from the collective memory. Lading Place Coppice, abutting the site of the wharf at Curbridge from which it took its name, came to be called Landing Place Coppice, thereby all but erasing the historical significance of the name. But still the woodland industries have left their mark, and not just in the obvious ways: the woodland tracks that still run down to the waterside; the hards

50 *Woodland scene in the 19th century at Freehills between Bursledon and Botley on the west bank of the Hamble.*

on the river; the 'ghost' of a sawpit near Dock Creek. Their effect can also be seen in some of the fine buildings in the area's villages and hamlets, the house of John Clewer, the timber merchant, at Durley, and that of John Guillaume, the timber and hoop merchant in Botley, for example. These buildings exude an air of mercantile prosperity; they are an elegant reminder of the beneficial combination of wood and water that the valley provided.

'A River Almost Unique in Character'

The 'Upper' part of the Hamble has long since been admired for its natural beauty. But it is still slightly surprising to find, sitting rather awkwardly in a late 18th-century trade directory under the entry for Botley, along with details of tradesmen, fairs and coach times, a long and effusive description of this part of the river couched in the ornate language of the picturesque:

> The river … is become a source of riches and a scene of pleasure to the inhabitants. Though narrow at Botley, it soon begins to swell its breadth, and in its course of three miles exhibits often an air of grandeur, softened by some of those beautiful tints which characterise the pencil of Claude. Its form is meandering; and its banks are diversified on each side by woods, whose nodding foliage, reflected on the bosom of the liquid element, gives ample pleasure to the contemplative mind. The views are many of them finely picturesque: from the flux and reflux of the tide, they assume a pleasing and perpetually-varying aspect; and, though they seldom rise into those sublime and romantic prospects which successively strike the eye of the traveller with astonishment and wonder, when gliding along the smooth and unruffled surface of the Wye; yet each has its particular beauty, and each presents a pleasing evidence of the greatness and benignity of that Artist who has so diversified his scenes to yield us satisfaction, and increase our felicity.

51 *Half-finished sketch of river looking south-west from the mouth of Curbridge Creek, c.1830. Although incomplete, it does show the 'side-screens', formed by the projecting banks, that would have appealed to a connoisseur of 'picturesque' landscapes.*

Mary Russell Mitford saw this same stretch of the river 10 years after the entry had appeared in the trade directory. 'The fields lay along the Bursledon River', she wrote of Cobbett's riverside fields, 'and might be shown to a foreigner as a specimen of the richest and loveliest English scenery.' Mitford almost certainly had the two fields called Carter's Croft – Upper and Lower – principally in mind. Cobbett had other waterside fields, but these first two fields, which are the site of the Romano-British villa, command views over the confluence of the main river and the Curbridge tributary, an area called Spinster's Lake.

The river between Botley and Bursledon has largely escaped development and the whole of the estuary, and its banks, are protected by various environmental designations intended to protect its woodlands, saltmarsh and mudflats. In the early part of the last century there were, of course, no such protections, and the Town and Country Planning Acts had not yet come into existence; there was the strong possibility, therefore, of some of the riverside fields and woodland being sold off as building land. The fact that this did not happen was largely due to the striving of Hugh Jenkyns, a local landowner, who was instrumental in getting the National Trust to acquire a long strip of land on the east bank of the river.

Jenkyn's efforts to preserve the Hamble seem to have begun in 1911 when he sought the assistance of the National Trust in preserving the woodland on the west bank of the river. Nothing came of this because, it seems, Jenkyns very quickly saw that an appeal by the Trust to the landowner might have been counter-productive. (Much later these woods were acquired by Hampshire County Council as part of Manor Farm, and now form part of the 400-acre Manor Farm Country Park.)

52 *Hugh Hobhouse Jenkyns (1880-1947). He was largely responsible for persuading The National Trust to buy and preserve waterside land at Curbridge in the 1920s.*

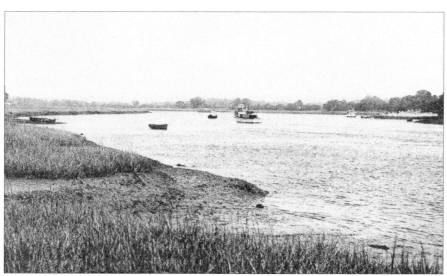

53 *Early 20th-century view of Hamble above Bursledon. It shows the river before the M27 was built.*

In 1926, Jenkyns again made contact with the National Trust. He had heard that, following the death of its octogenarian owner, Augusta Burrell, a well-known philanthropist, the Fairthorne Manor Estate was to be sold. It was not an uncommon situation. After the First World War there was what has been called a 'revolution in landholding' as the landed class, burdened by high taxation, were forced to dispose of property. Augusta Burrell's heir, a Major Charles Randolph, already owned the Kitnocks Estate, a property that had been given by her to his late wife, Edith, as a wedding gift. He sold the greater part of the inherited estate, including the main house that had been built on some of the land of Fairthorn Farm in the 1850s by a barrister called Clement Milward Q.C., to an Anglo-Irish family called the Barringtons. However, a long stretch of riverside land from the upper boathouse of Fairthorne to the field running to the old lading place called Eyersdown Hard, as well as both sides of Curbridge Creek, was offered for sale separately, some of it being advertised as building plots.

Almost immediately, the National Trust expressed interest in acquiring the land, B.W. Horne, its solicitor, saying that although he had seen many beautiful places 'secured to the nation' by the Trust he had seldom seen a more beautiful spot. However, it was then a relatively young organisation – it had only been founded in 1895 – and was not able to proceed with the purchase without local fundraising. Jenkyns responded quickly and generously. He and his wife bought and gave, in memory of their daughter, Priscilla, who had died of pneumonia while away at boarding school, the two areas of woodland, Harmsworth Row and Eyersdown Coppice. At the same time the Hamble River Preservation Scheme was set up to raise the money needed to acquire the rest of the land. Its committee comprised leading figures from the neighbourhood including Alfred Pern, the Botley doctor, Admiral Sir Richard Phillimore, Jenkyns himself and his wife, and William Garton, who also owned land by the river.

Major Randolph had agreed to exclude the land from the auction, due to take place in July 1927, if it could be demonstrated that the National Trust would be able to raise the funds necessary to acquire the 70 or so acres it was interested in. His terms were probably not ungenerous. The sale price was based on a probate valuation and no doubt less than the land's value in the open market. However, even with Jenkyn's generous donation, there was, with the legal and other expenses, over £1,700 to be raised. The fundraising was obviously successful as the National Trust acquired an option to purchase the land. Even then, there were difficulties to overcome. Randolph tried to withdraw Landing Place Coppice from the sale and Jenkyns notified the Trust of a rumour of a scheme to dam the river to improve the boating. It was no doubt a great relief to all concerned with the acquisition when in June 1929 the purchase of the property (including Landing Place Copse) was finally completed.

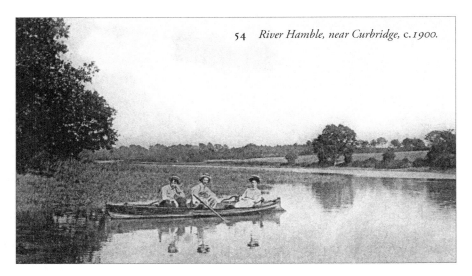

54 *River Hamble, near Curbridge, c.1900.*

The history of the National Trust's purchase explains the linear nature of its holding: it only acquired such land that was felt to be necessary to preserve the beauty of the river. Now, in the knowledge of the manner of its acquisition, it is difficult to go there, particularly in the spring of each year when the surge of new growth takes place and the floors of the coppices are crowded with primroses, wood anemones and bluebells, without silently giving thanks to the local people who fought to achieve, and partially funded, the purchase.

The remarkable Hugh Jenkyns appears to have been the prime mover in all this. Born in 1880 of a family of distinguished lawyers and churchmen and educated at Winchester College, he served for 25 years in the Indian Civil Service. He married Violet Winifred Austen-Leigh, a great-great niece of Jane Austen. As well as being involved in local government and serving on various committees, he took, as a landowner, a particular interest in the small farmers and growers of the area, letting land for smallholdings and allotments. Tragically, he was to die in a shooting accident on his estate at Botley in 1947.

Jenkyns undoubtedly loved the Hamble. In a letter he sent to the National Trust in 1911, he wrote of, 'a river almost unique in character & every year frequented by an increasing number of lovers of beautiful scenery …' Earlier in the same letter, he observed, in relation to the woodland on the west bank – Dock, Foster's and Catland Coppices – that if its owner, a Mrs Clark, 'preserves the small strip of woods which can be seen from the river she will undoubtedly earn the gratitude of future generations'. In the event, it was Hugh Jenkyns himself, so vigilant and earnest in his desire to save a cherished local place, who was to earn that gratitude.

PART THREE

The Bursledon River: Bursledon to Hamble

ORIGINS AND ARCHAEOLOGY

There are prehistoric hand-axes on display in the Westbury Manor Museum in Fareham. Roughly the size of a man's hand, one can see how they have been worked, or, to use the technically correct term, 'knapped', to make a viable tool to cut flesh or bone. It is one of an important cluster of such hand-axes that have been found in and around Warsash in the last hundred years or so, largely as a result of gravel extraction. Their precise age is not known but they are from the Palaeolithic period or Old Stone Age. As such, they are probably the oldest man-made artefacts ever found in the area.

These stone axes may seem a somewhat meagre showing for man's, albeit intermittent, presence in the area over hundreds of thousand years, but such stone tools, along with a few bones and teeth, are virtually the lock, stock and barrel of Palaeolithic archaeology. That they should have survived at all is remarkable. Our prehistoric ancestors who made these tools occupied a landscape very different from the one we see today. The Palaeolithic period coincided with the Ice Age, a period of dramatic change with alternate very cold and warmer periods that could each last fifty to a hundred thousand years. Although the ice never covered what is now southern England, it is likely that during the very cold periods the ancient humans would have deserted what is now the British Isles. During the warmer periods (the interglacials), the human population returned but would probably never have been more than about five thousand or so.

The finds from Warsash and other places along the Solent show that the Hampshire Basin was a favoured place for human occupation – settlement would be the wrong word to describe such a peripatetic, hunting existence – and the accumulation of Palaeolithic material at certain locations may been left by groups of people making repeated visits to the same spot. Palaeolithic occupation in southern England favoured, it seems, the river valleys, where there was a secure supply of fresh water and of animals and fish to hunt and catch, rather than such areas as chalk downland, where Palaeolithic finds are relatively scarce.

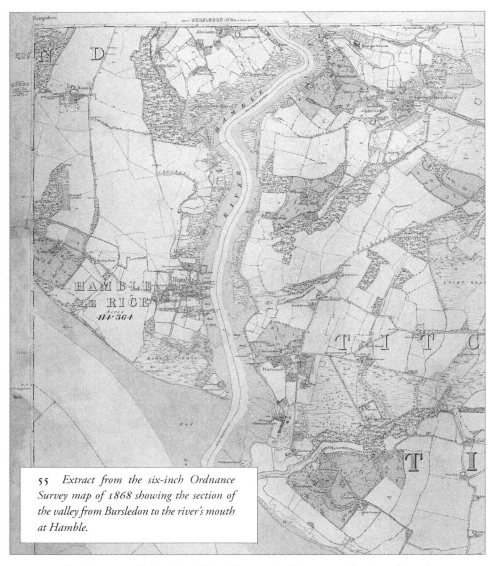

55 *Extract from the six-inch Ordnance Survey map of 1868 showing the section of the valley from Bursledon to the river's mouth at Hamble.*

In the case of the Hamble valley and other areas that border what is now the Solent, occupation was no doubt linked to the presence of the ancient Solent River. This long vanished Palaeolithic river-system extended across the whole of what is now southern Hampshire and East Dorset, and connected with an even larger river system that drained the area of the English Channel, which was then land. As was noted in the first chapter, the Solent River was drowned, or last drowned, by the sea about 6,000 to 7,000 years ago as a result of the Flandrian Transgression. Only then did the landscape acquire its present relatively settled form. Before that, during the Palaeolithic period, it was still undergoing substantial change. During the glacial periods melt-water each spring caused rivers to down-cut and bring down huge quantities

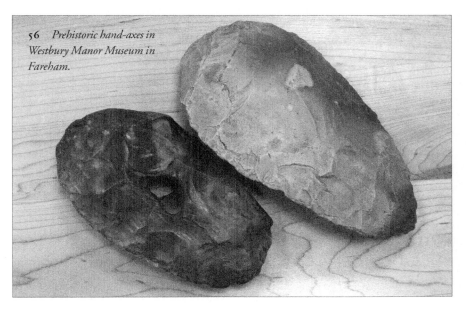

56 *Prehistoric hand-axes in Westbury Manor Museum in Fareham.*

of gravel, sand and loam, which had to be distributed. This resulted in the series of gravel terraces that cover much of the Hampshire Basin. Geologists can give some indication of the age of these terraces, providing the latest date for the age of the hand-axe or other artefact in question, but, and this is where the archaeology of the Lower Palaeolithic becomes complicated, the process by which the terraces was formed may mean that the finds may have been moved some distance before being bedded in the gravel. The degree of abrasion suffered by the artefact may give some indication as to how far it has travelled, but clearly this is a less stable archaeology than that of later periods. Archaeologists are wary about ascribing an age to the hand-axes from the mode of construction, but, on the basis of their location within certain river terraces, it is estimated that they are over 200,000 years old.

It should be remembered that the men who made the hand-axes found at Warsash were not modern humans but the ancestors of both ourselves (*Homo sapiens*) and Neanderthals (*Homo neanderthalensis*). By the beginning of the Mesolithic (*c.*8,500-3,500 B.C.), in relative terms a huge leap forward in time, we can be fairly sure that there were modern humans hunting and fishing along the banks of the Solent River, which was drowned by the sea during this period. There is some evidence, in the form of microliths – small, specialised flint tools – that they hunted along the Hamble valley. Flint tools have been found on the western bank of the river around the sewage works, at its confluence with Curbridge Creek, and also in two places on the upper reaches of Shawfords Lake around Shedfield; and this is consistent with the generally held view that Mesolithic communities favoured the sides of rivers and lakes for settlement. The clay

areas generally appear to have been avoided but the river would have been a convenient way-finder as well as a place to hunt and fish.

There is little evidence of human occupation along the banks of the Hamble during the Neolithic (c.3,500-2,000 B.C.). By then, farming was beginning to be introduced, but the heavy clays of the valley would have been hard to work without metal tools and no doubt people preferred to occupy the lighter soils of the chalk rim of the Hampshire Basin. However, there is more extensive evidence of occupation during the Bronze (c.2000-650 B.C.) and Iron Ages (c.A.D. 650-34) by which time metal technology had been developed. Bronze-Age tumuli have been found on Netley Common and the rampart and ditch of an Iron-Age promontory fort can still be seen on Hamble Common. However, one of the most remarkable finds of the Bronze Age was made by employees of the Bursledon Brick Company at the corner of Peartree Copse on what historically had been Swanwick Farm. In 1927, while extending the clay workings, they discovered a deep shaft. An examination of this pit revealed that it contained, as well as the clay infill, a number of loom weights, the fragment of a quern and, about 10 feet down, a layer of charcoal that subsequent analysis revealed had been made by burning wood from oaks, hazels and alders, trees indigenous to the valley. The following year further work was carried out in the same part of the workings and it was discovered that the pit found the year before had only been partially excavated. It extended further into the ground and had a depth of 24 feet and narrowing to a shaft. At the bottom was an undressed oak post and the material around it was darker in colour than the grey clay of the upper levels. This material had a strong, repellent smell, like the "roke" off river marshlands on sultry nights', and the workmen claimed that on first digging into it 'it stank enough to knock you down.'

Even in the 1920s the idea of this being a 'refuse pit', a mere repository for rubbish, was not wholly accepted, and it was clear to archaeologists of a later generation that this was a ritual site, mirroring one found at Holzhausen in Germany. The German site also comprised a pit with a wooden post at the bottom packed with material that included traces of blood, flesh and animal fat. What do these finds signify? Probably they were sacred sites where rites, perhaps involving sacrifice, took place. It is perhaps relevant that the site was close to the Hamble, just 600 yards to the west. Rivers and springs, together with wells and pits, were of great significance in prehistoric religious practice. Equally, certain trees, such as the oak from which the Swanwick post was made, were considered sacred.

One of the most remarkable finds in recent years, and one directly connected with the river itself, was the curse tablet that was found on the

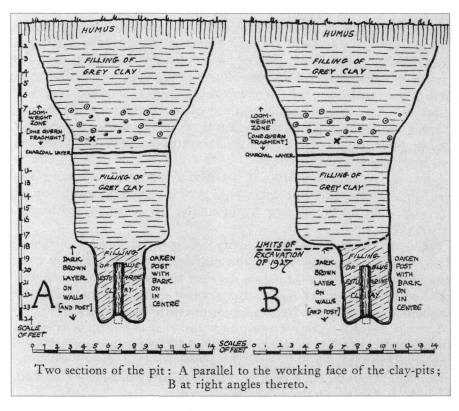

Two sections of the pit: A parallel to the working face of the clay-pits; B at right angles thereto.

57 Drawing of burial pit at Swanwick.

eastern side of the Hamble estuary by Norman Owen in 1982 using a metal detector. Acquired by Hampshire County Council, it is now on display in the Westbury Manor Museum in Fareham alongside the Palaeolithic hand-axes. The translation of the words scratched on it reads:

> Lord Neptune, I give you the man who has stolen the *solidus* and six *argentioli* of Muconius. So I give the names who took them away, whether male or female, whether boy or girl. So I give you, Niskus, and to Neptune the life, health, blood of him who has been privy to that taking-away. The mind which stole this and which has been privy to it, may you take it away. The thief who stole this, may you consume his blood and take it away, Lord Neptune.

From the style of the script and the types of coin referred it has been concluded that the tablet dates from after A.D. 350 in the reign of Valentinian I, towards the end of the period during which the Romano-British site at Curbridge appears to have been occupied.

That the tablet should be addressed to Neptune, the Roman water god, is unsurprising. Appeals to him have been found on curse tablets found in

three other rivers; the Ouse, Thames and the Tas, and even though by the time the tablet was thrown in the Hamble the Roman empire was officially Christian, the old gods were not easily forgotten. That the appeal should also be made to Niskus is more intriguing. R.S.O. Tomlin, who transcribed and dated the tablet, conjectured that Niskus is another, older name for the Hamble itself, but concluded that Niskus was probably a celtic water-god, either local to the vicinity – it was not unusual for the Celts to associate goddesses, if not gods, with rivers – or of having wider importance, perhaps a Celtic equivalent of the Roman Neptune.

Another important find on the Hamble is Saxon, dating to the late 7th or early 8th century A.D. (A.D. 668–704), not long before Bede wrote his history mentioning the river. This is the logboat, found on the banks of the promontory of land between Curbridge Creek and Shawfords Lake. It was discovered by workmen constructing a new boat-

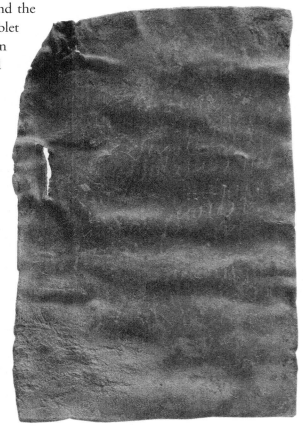

58 *Late fourth-century A.D. leaden 'curse tablet' found on foreshore of Hamble estuary in 1982.*

house on the Fairthorne estate in the autumn of 1888. They dug out of the mud what they took to be a bog oak but, on further examination, it

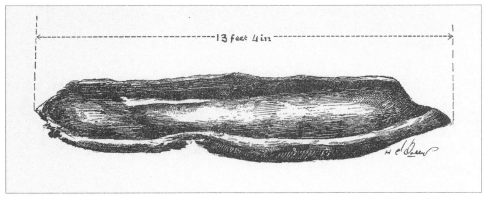

59 *Logboat found on the Fairthorne estate in 1888.*

appeared to be a prehistoric canoe. This logboat, which is now in the care of Southampton City Council, had at the time of its exhumation from the mud a length of 13 feet 6 inches and a width of 2 feet 6 inches, but it has subsequently shrunk, presumably as a result of the drying process.

Logboats, burial pits and curse tablets, they are all closely connected with the river. However, at the beginning of the 21st century, it is the wider archaeology of the prehistoric that seems to have the greater resonance. As the debate on climate change rages, and there is much talk about rising sea-levels, the great climatic extremes that were endured in the past begin to have an entirely new relevance here on this 'fragile, fugitive coast'. What was once land is now water, and much of the archaeology of the Mesolithic is to be found under the sea. Water levels have been rising since the 18th century, eroding the salt marsh along the Hamble and other parts of the Solent, and we can only wonder what the future holds for us.

BRIDGES AND FERRIES

By the 18th century the existence of bridges at Botley and Curbridge meant that it was possible, with relative ease, to skirt round the head of the estuary. The bridges at Botley have been discussed in an earlier chapter and the bridge at Curbridge was an ancient crossing of Curbridge Creek, as the place name implies. Here one can still see below the modern bridge the footings of the medieval bridge, which is the one shown on Saxton's map of 1575. This

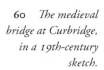

60 *The medieval bridge at Curbridge, in a 19th-century sketch.*

61 *Extract from a 17th-century map of the valley showing Bursledon Ferry.*

two-arched stone bridge was not replaced with the iron structure until 1890. However, below Botley, travellers wishing to cross the main river had to use the ferries at Bursledon and Hamble.

The Hamble ferry, which still runs between there and Warsash, is of some antiquity. For many years, it has been kept by Ray Sedgwick, but he is only one of a long line of ferrymen. As early as the 1530s, John Leland, the Tudor scholar and antiquarian, used it to cross the Hamble on his journey from Southampton to Titchfield, and it is likely that the ferry would have been in existence before this in the medieval period, to answer the need of passengers to cross the estuary. At the meeting of the Admiralty Court for the length of coast between Netley and the mouth of the Meon on the Hamble foreshore on 15 August 1572, it was reported that 'thos that kepe the passage botts [ferry boats] both one this side at Hamble and also on th'other side at Wersashe is so necligently kepte that at dyvers tymes the travelers that shuld passe that wayes over one bothe sides is dryven to tarry ii or iii howrs before they cane gett over.' The ferrymen, John Webbe, Henry Osman and Richard Marshall at Warsash and John Dalamor at Hamble were each fined 12d. At the same time it was recorded that by ancient custom the cost of passage at Bursledon and Hamble for a man with a horse was 1d.

In 1579, the court ordered Richard Marshall to repair the ferry hard at Warsash on pain of a 20s. fine. Another complaint about inordinate delays appears to have been made in respect of the Bursledon Ferry in 1579, it

being reported that the ferry was 'verie ill kept'. It was probably a perennial complaint made about any none too diligent ferryman. And perhaps the two young men who, 200 years later, in going to Portsmouth in September 1772, were 'too impatient to wait for the boat at Bursledon ferry' and attempted to swim their horses across were not entirely to blame when one of them, 'in endeavouring to turn his horse too short', was flung off and narrowly escaped drowning. Fortunately, he was able to catch hold of his horse's mane, and the animal carried him safely ashore.* Sometimes in bad weather the ferries did not run at all. In the petition to Parliament for the bill to build a bridge over the Hamble at Bursledon, it was claimed that 'from the Violence of the Winds and Sea' passage across the rivers Itchen and Hamble was 'frequently totally prevented'.

Bursledon Ferry features peripherally in a 16th-century historical episode. In the autumn of 1594, the 3rd Earl of Southampton, using his local influence and resources, provided shelter to an escaped murderer, Sir Henry Danvers, and his brother, Sir Charles. Both men had fled to Titchfield after the killing of Henry Long in Corsham in Wiltshire. Southampton had accommodated them at Whitley Lodge, a house in the deep woodland to the east of Burridge. Just before sunrise on Tuesday 8 October, the Earl and others escorted the two men to Bursledon Ferry where the fugitives boarded a boat belonging to a Henry and William Reed and were carried across to the Isle of Wight. This appears to have been a largely fruitless expedition and after two days away, including a night spent anchored in the Reeds' boat opposite St Andrew's Castle near the mouth of the Hamble, the two men returned to Titchfield. Eventually, they were able to escape to France.

The ferry at Bursledon continued to operate for the next 200 years. The botanist John Goodyear recorded the plant Sea Heath, *frankenia laevis*, growing 'on the ditches bancks of Bursledon Ferrey' on 3 September 1621 and the ferry is marked on Dummer and Wiltshaw's map of 1698. However, by the late 18th century it was recognised that a bridge over the estuary was sorely needed. It was not just the inconvenience of the ferries; the lack of a bridge was seen as impeding the economic development of the area at a time of 'great Increase of and still increasing Population and Trade of the Town of Southampton and its Neighbourhood'.

In 1796 an Act had been passed authorising the construction of a bridge across the Itchen at Northam. This prompted the leading inhabitants of the parishes alongside the Hamble estuary and others, including George Parsons, the shipbuilder we shall encounter in the next chapter, and Walter Taylor, the maker of lightweight pulleys that made British warships easier to manoeuvre,

* Local tradition has it that a ford or shallows were maintained close to the Bursledon Ferry by laying down brushwood to allow cattle and other stock to be taken across the estuary at the low tide.

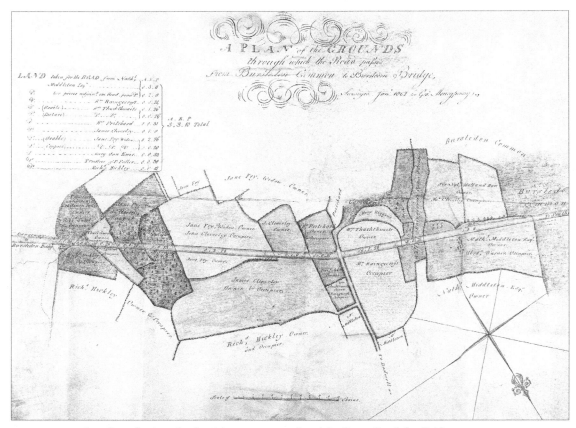

62 *Reproduction of early 18th-century map of roads leading to Bursledon Bridge.*

to petition Parliament. They were arguing for leave 'to bring in a Bill for building a Bridge over Bursledon River at or near the Ferry at Bursledon' and for making roads to link it with the Southampton and Park Gate, including, to the west, the roads of the Northam Bridge Company. Previously the Itchen-Hamble peninsula had only been served by parish roads. Most wheeled traffic had a roundabout journey to Portsmouth via Bishop's Waltham and Fareham to avoid crossing the Hamble estuary. The Act was passed on 19 July 1797.

Interestingly, Isaac Galpine, the solicitor who was the clerk of the Bursledon Bridge Company from its formation until 1804, appears to have had a personal interest in the project. As the preamble to the Act makes clear, Galpine, along with another instigator of the scheme, held on trust under the will of the late William Galpine, late of Romsey, Common Brewer that, 'according to the Custom of the Manor of Swanwick', the 'Ferry and its Appurtenances' between Swanwick and Bursledon and were 'willing that the said Bridge shall be built at or near the said Ferry'.

The bridge, which was designed by a George Moneypenny, was to be of a timber trestle construction. There were, as the engravings on the early share

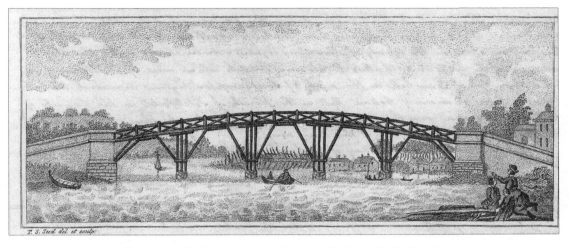

63 *Engraving of bridge on share certificate issued by Bursledon Bridge Company, 1815.*

certificates of the Bursledon Bridge Company show, to be two trestles or piers that divided the arch into three spans: of 58 feet in the centre and 50 feet on either side. The clearance of the central span was to be 29 feet. The contractors employed were Messrs. Samuel & William Lister of Bramley, near Leeds. The Bridge was opened in July 1800 and the sum of £125 18s. 7d. was earned in tolls during the second half of that year. However, one should not assume from the fact that the bridge was built and in use within three years that its construction was a straightforward matter. A further Act had been required in 1801 to empower the Company to raise more money. The first Act had permitted the sum of £8,000 to be raised by issue of shares and on mortgage. The 1801 Act permitted the raising of a further £7,500. The petition for this Act referred to 'the extreme difficulty which attended the forming a foundation for the Bridge in the sides of a considerable River, strongly affected by the Tide, and consisting of mud and clay of considerable depth ...', and mentioned the unforeseen expenses that had been incurred.

We can assume from this that the construction problems that were to dog the bridge during the early 1800s had very soon become apparent. The Bursledon Bridge Company had to spend substantial sums sorting out these structural difficulties over that first decade. In an interesting article that appeared in 1995, Joyce Moore pointed out that the appearance of the bridge in the engraving of it that appears on one of the Company's share certificates differs from that on what is almost certainly an earlier print. The latter, consistent with the original specification, shows two piers supporting the bridge, whereas the 1815 share certificate shows the four supporting piers that we are familiar with from 20th-century photographs of the river.

The problems that were to cause the bridge to be re-modelled appear to be the ones that John Rennie (1761-1821), the great engineer who was to design Waterloo Bridge in 1817, analysed in a report he wrote in the early 1800s.[*] Both the western and eastern sides of the bridge were affected, but the most significant concern was with the abutment on the Bursledon side. Here the weight of the abutment and the causeway were too much for the soft river mud and the abutment slipped forward about 3½ feet into the river. The driving of piles between the abutment and the river were ineffective to prevent this. The dumping of 1,600 tons of stone in and around the abutment did stop its further progress, but had the effect of blocking the river almost as far as the first wooden pier.

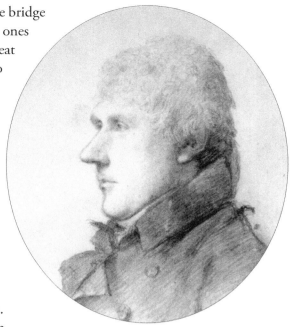

64 *Portrait of John Rennie by George Dance, 28 May 1803.*

Rennie put forward two possible solutions to the problems he had identified in his report. The most radical was to remove the eastern abutment altogether and add another wooden arch. This would have meant that the abutment had a firm purchase on the bank and that 'the muddy beach which has given so much would be left entirely to itself'. He thought that 'the next best method consistent with economy' would be to remove the earth from the abutment and replace it with bavins (brushwood) to within 2 feet of the road and then top this with clay and gravel. He hoped that the mud would be able to support the reduced load, but he was still concerned that the contraction of the channel caused by the dumping of the stone might result in the grinding down or scouring of the bottom of the river, and cause the abutment to slide again.

It would seem, on the evidence of the engravings, that the more substantial solution was not adopted, at least straightaway. By the latter part of 1809, however, the condition of the bridge was again causing great concern. That the committee of the Bursledon Bridge Company met on Christmas Day may suggest that emergency action was required. During the next couple of years the very large sum of £1,485 18s. 2d. was spent in carrying out works. The

[*] The report is undated, but it appears to have been written in 1800 following an inspection of the bridges at Northam and Bursledon in August of that year.

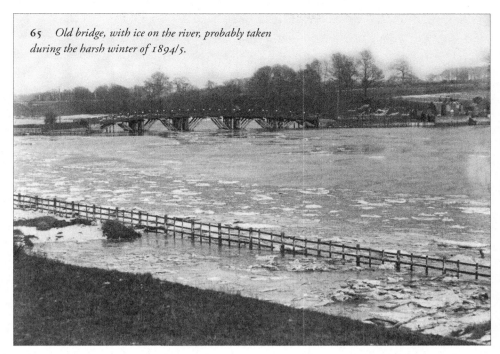

65 *Old bridge, with ice on the river, probably taken during the harsh winter of 1894/5.*

contractor was George Parsons. The records of the Bridge Company show that the expenditure included the cost of freighting, loading and carting stone. Caissons, water-tight, open-topped wooden boxes, were employed in constructing foundations and it seems likely that at this time the additional piers and the stone starlings to protect the piers were added.

It would seem that the works carried out in 1810 solved the constructional problems and for the next 30 years the bridge company received, either by

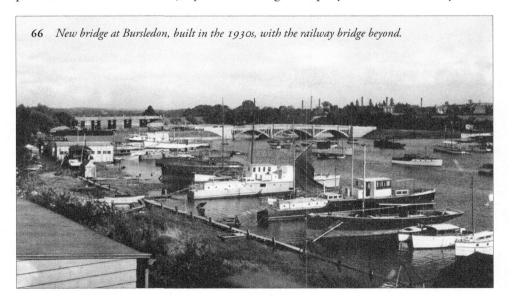

66 *New bridge at Bursledon, built in the 1930s, with the railway bridge beyond.*

leasing the tolls or collecting them directly, well over a £1,000 a year. Tolls, though, reduced substantially after 1843 and a moment of apparent crisis came in 1883 with the proposal to extend to Fareham the Southampton to Netley Railway, taking it across the Hamble. It was feared that this would reduce the revenue from the bridge and it was even contemplated invoking the clause in the 1797 Act that permitted the Bridge Company to take action against 'any person carrying for hire across the River between the Hamble Ferry and the Town of Botley'. In the event, £750 was accepted as compensation by the bridge company from the railway company and the tolls were not, in any event, affected greatly. The bridge eventually came into public ownership and became the responsibility of Hampshire County Council in January 1931; it would become toll-free later that year. It was replaced a few years later with the present reinforced concrete, skeletal-arched bridge.

SHIPBUILDING

Thence at about four miles we pass another river at Bussleton, narrow in breath, but exceeding deep, and eminent for its being able to carry the biggest ships: Here is a building yards for ships of war, and in King William's time, two eighty gun ships were launch'd here. It seems the safety of the creek, and the plenty of timber in the country behind it, is the reason of building so much in this place.

Daniel Defoe,
A Tour through the Whole Island of England and Wales, 1724-6

There is an oil painting by J.M.W. Turner at Petworth House in West Sussex called *Teignmouth Harbour*. A girl with outstretched arms is seemingly trying to drive or cajole two cattle in the foreground, but the canvas is dominated by two half-built wooden warships rising out of the mist. The picture is dated 1812, at a time when Devon shipbuilders were first beginning to win contracts to build for the Navy. We can imagine such sights on the Hamble. Not only did the Hampshire river have a longer pedigree in naval shipbuilding – ships had been built for the Crown at Bursledon in the 1690s – and there is a wealth of documentary evidence of naval shipbuilding then and at later times, but, at about the same time that Turner was making sketches for his painting, an unknown artist was painting a watercolour sketch of a similar scene from the bridge or one of its approach roads looking downriver to Bursledon Point. It shows a warship at approximately the same stage of construction as the Teignmouth vessels, shipwrights clambering over the half-finished hull. Artistically inferior to the Turner, of course, it does have the historical virtue of being precisely dated – 17 October 1810, and we can be fairly certain that it shows the 74-gun *Rippon*, which was being built at

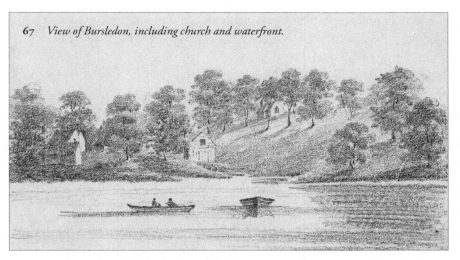

67 *View of Bursledon, including church and waterfront.*

that location by the shipbuilding firm of Blake and Scott, eventually being launched in 1812.

The Napoleonic period was undoubtedly the high point of naval shipbuilding on the Hamble, the culmination of 100 years of such activity that had begun with the launching of the 80-gun *Devonshire* in 1692. Long before this, in the Middle Ages, the river was seen both as a suitable site for building ships as well as a safe anchorage. The *George*, which was to be involved in the Battle of Sluys, was launched on the river in 1338 in the presence of King Edward III. A hundred years later, in 1435-6, the balinger *Petit Jesus* was re-built at Bursledon. In the reign of Henry V, Southampton served as the administrative centre and base for the royal fleet – the King's ships had sailed from there to France in the summer of 1415 for the Agincourt campaign – and the Hamble provided overflow accommodation. In the winter of 1417, 12 royal vessels were anchored there, protected by a force of 40 archers. This was not, it seems, an infrequent event. In 1418, William Soper, a Southampton merchant and member of parliament, who was successively 'surveyor' and, from 1420 to 1442, Clerk of the King's Ships, built a wooden bulwark at Hamble, garrisoned by a force of specially mustered men, to protect the anchorage. Soper supervised the construction of a number of ships for the King including the *Grace Dieu*, a high-sided, 1,400 or so tun[*] vessel intended to neutralise the potent effect of the high-sided carracks of Genoese, then allied to the French, as well as a barge and a balinger. With the death of Henry V in 1422, though, the majority of the late King's ships were sold. Only his so-called 'great ships' – *Trinity Royal, Holy Ghost, Jesus* and the *Grace Dieu* – being mothballed and retained, and eventually moved to mud berths on the Hamble. Three of the vessels never, it seems, left the

[*] A tun was a measurement related to a wine container of 252 gallons.

river and the remains of the *Grace Dieu* and possibly another ship, the *Trinity Royal* or the *Holy Ghost*, have been located. The wreck of the *Grace Dieu* lies close to the east bank opposite Catland Copse, its position indicated by a navigation marker. With a mast that is estimated to have been 204 feet long and a circumference of 22 feet, this leviathan would have been a remarkable sight laid up on the Hamble. It was destroyed by fire caused by lightning in 1439, burning down to the waterline, but a great quantity of iron was subsequently recovered from the vessel.

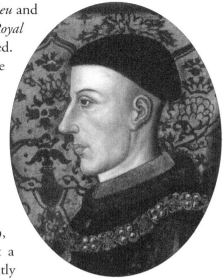

68 *Portrait of Henry V.*

Southampton's status as a naval base declined sharply after Henry V's death, and Portsmouth, where Henry VII established a royal dockyard, eventually supplanted it, becoming the leading naval port of the region. However, royal ships sometimes made use of the Hamble as an anchorage and in 1698 the 'Bussleton River' was one of 18 places on the south coast that were considered as the site for a new naval

69 *Survey work being carried out on the wreck of* Grace Dieu, *c.1984.*

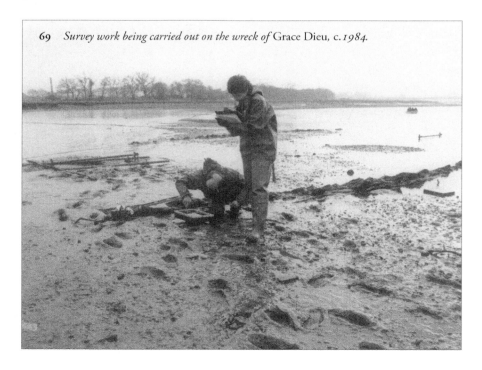

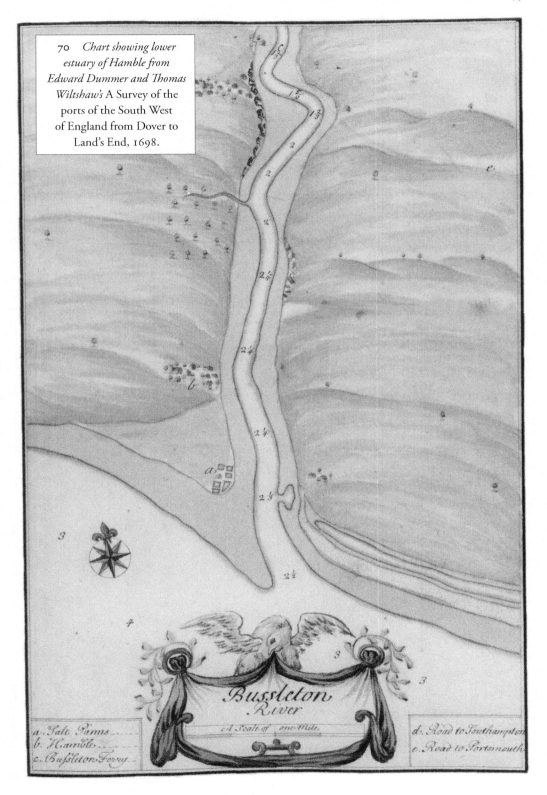

70 *Chart showing lower estuary of Hamble from Edward Dummer and Thomas Wiltshaw's* A Survey of the ports of the South West of England from Dover to Land's End, *1698.*

Busslcton River

A Scale of one Mile

a. Salt Pams
b. Hamble
c. Bufslcton Ferry

d. Road to Southampton
e. Road to Portsmouth

base. Nothing came of this but the report entitled 'A Survey of the ports of the South West of England from Dover to Land's End, 1698' contained a beautifully drawn and coloured map of the lower estuary, complete with ornate cartouche and compass rose, showing the varying depths of the river – $1^2/_3$ fathoms (10 feet) just above Bursledon and 2½ fathoms (15 feet) at the mouth. The Commissioners who carried out the survey included a Bursledon man, Thomas Wiltshaw. They pronounced it a 'small River' and its channel 'narrow but Deep and safe', observing that 'here likewise hath been Built some of the 80 & 60 Gun shipps with great Accommodation and Security'. The depth of the water and the safety of the river were qualities that Daniel Defoe stressed in his *Tour through the whole Island of Great Britain*, published in the 1720s, though he also added an extra advantage: 'the plenty of the timber in the country behind it'.

A.J. Holland, the historian of naval shipbuilding in Hampshire in the 18th and 19th centuries, argued that the Hamble's attributes – its course, 'shaped like a swan's neck', affording shelter from the westerly winds; its mouth, dangerous to navigate for those unfamiliar with it, and thus affording security; the outcrops of gravel in places along its length that provided launch sites; and the availability of timber in the river's hinterland – were not unique to it, and there were many other places on the coast of England that had such facilities. They do not, he said, explain the use made of the river for naval shipbuilding, which he ascribes to other factors: in the 14th century, to a shipbuilding programme being centred on Southampton; in the 18th century, its proximity to the dockyard at Portsmouth and that there were local men with the necessary expertise and capital. However, this argument can nearly be turned on its head. A local tradition of shipbuilding implies that it had long been recognised as a good location to build ships. And it was not just warships that were built there. In 1648, for example, a 60-ton barque, capable of making a voyage to Barbados, was built as far up the estuary as Curbridge, and one of its builders was a shipwright called William Oxford of Titchfield. In the following century sloops and small fishing vessels continued to be built on the river.

The 80- or 60-gun ships referred to by both Defoe and in the report of the 1698 Survey were part of the building programme of 27 ships, financed by duties on beers and spirits, ordered by Parliament in 1690. The royal dockyards could not have coped with such a large order and the construction of some of the smaller vessels, third or fourth rates rather than ships of the line, was entrusted to private shipyards. Two Hampshire shipbuilders, John Winter and William Wyatt, were well-placed to win contracts. Distantly related as well as being friends, they not only had the requisite skill and experience but, perhaps more importantly, an acquaintanceship, at least, with

Edward Dummer, who was the Surveyor of the Navy and had Hampshire connections. Although they contracted separately with the Navy Board, Winter and Wyatt appear to have acted in unison in obtaining timber and other supplies. Winter built four ships at his yard at Northam on the Itchen

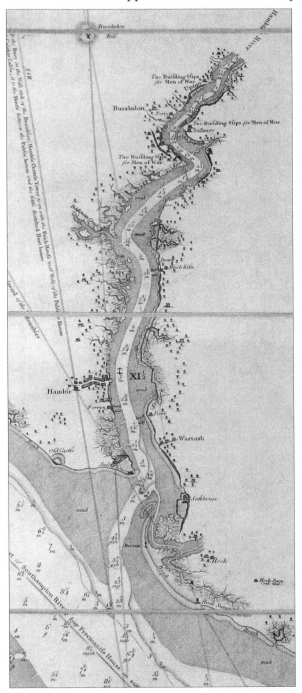

River. Wyatt, who was related to a landowning family in the Botley and Curdridge district, and his wife, Anne, who for a time carried on the business after her husband's death from smallpox in 1693, built four ships – the *Devonshire*, *Winchester*, *Lancaster* and *Cumberland* – at his yard at Bursledon. It seems that the 80-gun *Devonshire* was not well constructed. Sir Richard Haddock was 'troubled to find so great a ship so ill-built by the hanging of her deck abaft so low, beside the wrong she hath taken in launching …'

Anne Wyatt was unable to secure any further contracts from the Navy Board after completing the *Cumberland*, and this period of naval shipbuilding on the Hamble came to an end. Two minor literary associations provide a footnote to it. As well as his comments about shipbuilding in his *Tour*, Defoe also mentions in his novel *Captain Singleton* (a maritime romance published in 1720), 'a place not far from Southampton, which I afterwards knew to be Bursledon; and there I attended the carpenters, and such persons as were employed in building a ship for the … Newfoundland trade.' A.J. Holland

71 *Extract from Lieutenant Murdoch Mackenzie's 1783* Survey of Southampton River.

believed that Defoe was acquainted with the Wyatt family and had visited their shipbuilding yard in the 1690s. The intrepid Celia Fiennes, who journeyed throughout England between 1685 and 1703 and recorded her horseback travels in a journal, also mentions Bursledon: 'at Bursledon and Redbridge are the best shipps built.' However, as Holland points out, she was distantly related to the Wyatts, who built in both places, and her favourable comments may owe more to familial loyalty than objective opinion.

It is believed that the Wyatt family had ceased to build ships of any description at Bursledon by the 1720s and that in 1725 their old yard had been taken over by Philemon Ewer. Ewer was a master shipwright and timber merchant; his very name, the classicism of his first name balanced by the no-nonsense and sturdiness of his surname, seem to imply that he had both education and physical vigour, qualities that a practitioner of his trades, particularly that of shipbuilding, would require. Initially, it seems, he built and repaired small coastal vessels and fishing boats. With a fully equipped yard, he was well placed to be able to take on work for the Crown when, as a result of the War of Austrian Succession, the Navy Board again looked to merchant shipbuilders to help meet its requirements for fighting vessels. Over 140 vessels were built in private yards during the years 1739 to 1748 and over 20 per cent of these were built along the coasts of Hampshire and the Isle of Wight. Ewer's contribution was 10 vessels, ranging from the 60-gun *Anson* to the 14-gun *Lizard*. He appears to have been a successful practitioner of his trade and when he died in 1750, at the age of 49, his children erected in St Leonard's church at Bursledon an elaborate memorial to him made of marble, slate, plaster and wood, incorporating on the base a half-model of a ship. The inscription on the memorial speaks of an 'ingenious Artist and excellent workman and honest Man' and as having a 'fair character & a plentiful fortune'. His son succeeded to his father's timber and shipbuilding businesses and continued to use the old yards at Bursledon and Cowes.

72 *Wall tablet by J. Nutcher erected in memory of Philemon Ewer in St Leonard's church at Bursledon.*

Initially, at least, the Navy Board favoured the merchant yards on the Thames estuary. However, concerns about the high prices being charged by those yards seem to have prompted the decision to award more contracts to the so-called 'country builders'. This may explain why other Hampshire shipbuilders picked up contracts at this time. Richard Heather, who had been Ewer's overseer, was awarded two contracts that were performed at Bursledon. He built the 24-gun *Triton* in 1745 and the 44-gun *Assurance* in 1747 before moving his shipbuilding operation to Gosport. Ewer's former apprentice, Moody Janverin, also built two vessels for the Crown: the 14-gun *Hinchinbrook*, launched in 1745, and another small vessel, the *Badger*. Heather's and Janverin's naval shipbuilding ventures appear to have been successful. Certainly they carried on building ships for the Crown. In contrast, the partnership of John Smith and Joseph Snooks or Snooke fared less well. The 44-gun *Humber* was eventually launched in 1748, but only after the partners had been declared bankrupt and James Smith, John Smith's son, had taken over the contract and finished the ship.

With the return of peace in 1748, naval shipbuilding on the Hamble again ceased. This was only to be a brief hiatus as the Seven Years' War broke out in 1756. Only 74 ships were built outside of royal dockyards

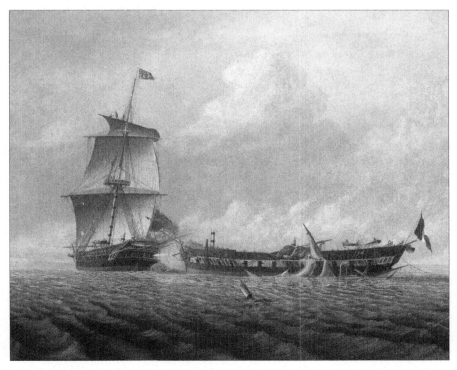

73 *Action between HMS* Blanche *and the* Pique, *5 January 1795. The* Blanche *was built on the Hamble and launched in 1787.*

during this war, a smaller number than during the previous hostilities. Of these only two were built on the Hamble, both built by Moody Janverin. However, if the Seven Years' War represents a relatively quiet period on the river, the next round of hostilities was not. The American War of Independence, which broke out in 1775, marked the beginning of an important period of shipbuilding that was to last to the end of the Napoleonic Wars. In 1780 the great George Parsons, doyen of the Hamble river shipbuilders, launched his first ship, the 32-gun *Fox*, and was to build five more before the end of the period of shipbuilding associated with the war. These included the 74-gun *Elephant*, the largest wooden warship built on the river. It was for a time commanded by Jane Austen's brother, Frank, and is one of the naval vessels mentioned in *Mansfield Park* and was Nelson's flagship at the Battle of Copenhagen. (And it was standing on her deck that Nelson famously applied his telescope to his blind eye.) Parsons appears to have had in abundance the qualities needed to be a successful shipbuilder. Intelligence and sound commercial judgement – he never

over extended himself by taking on too much work – were allied to a legendary physical strength. It was reputed that he was able to drive in a copper bolt with a single blow of the hammer and to be able to lift heavier pieces of timber than any of his workmen. One imagines a commanding physical presence, as much at ease with his men on the Bursledon waterfront as with the government officials with whom he dealt. His physical robustness is also attested to by his longevity. Still virtually in harness, he died in 1812 at the age of 82, a very good age for someone born in the first half of the 18th century. Parsons was also, it seems, well-regarded for his honesty. In a fulsome obituary, he is described as having, 'a high character for inflexible, undeviating, integrity; and, the punctuality and uprightness with which he performed his Contracts with the

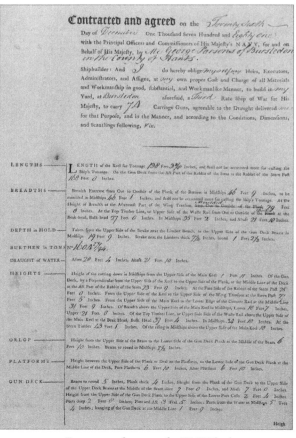

74 *Front page of contract for HMS* Elephant.

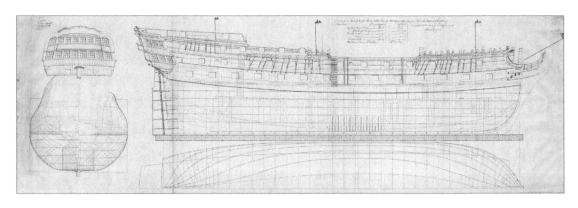

75 *Plan of HMS* Elephant.

Government in the building of ships of war for the Navy, gained him the esteem of the Navy Board …'

Peace returned in 1783 and after completing the 44-gun *Dover*, which was launched in 1786, Parsons turned to completing an East Indiaman and several small merchant vessels. But the period of peace ended in 1793, with the outbreak of war with Revolutionary France, and he was again hard at work on naval contracts. Six vessels were built by Parsons between the outbreak of war and 1801: *Diligence, Galatea, Cambrian, Penelope, Jason* and *Resistance*.

It might have been expected that there would have been a continuous period of naval shipbuilding throughout the period of the Revolutionary and Napoleonic Wars. Apart from a brief lull caused by the Peace of Amiens, Britain was at war from 1793 to 1815, a period of over twenty years. However, political events caused a temporary cessation in naval shipbuilding in private yards, and no warships were launched on the Hamble between 1801 and 1804. This is because Lord St Vincent, the First Sea Lord appointed by the Addington administration, disliked and distrusted private shipbuilders. It was only with the coming to power of the Pitt Government in the spring of 1804 that this policy was reversed and a major programme of

76 *Figurehead of HMS* Apollo.

building in merchant yards began. Between May 1803 and November 1815, a total 433 ships with a combined tonnage of 242,619 were built in private yards. A total of 87 ships were built on the coasts of Hampshire and the Isle of Wight and 15 of these were built on the Hamble.

With the removal of the embargo on awarding contracts to private yards, George Parsons was again active. The 36-gun *Tribune* was launched at Bursledon in 1804; the *Fly* in the same year; the 36-gun *Apollo* in 1805 and the *Horatio* in 1807. The *Apollo* was completed early, earning Parsons a premium of £500. However, he then suffered a setback, losing the lease of his yard to Richard F. Stiles Blake, hitherto a foreman shipwright at the Woolwich yard, who had entered into a partnership with a John Scott, at one time Nelson's secretary. Despite being in his 74th year, Parsons was undeterred, quickly establishing a new building site at Warsash, creating launchways made of elm timber and re-locating a graving shed and mould loft from the western bank. This interruption caused him to be late in completing the *Peruvian* and the *Hotspur* but his punctuality was soon restored, completing the 36-gun *Theban* in 1810 and the 36-gun *Nymphe* in 1812 on time. The latter was launched two days before Parsons' death.

While Parsons had continued to flourish after the move to Warsash, the partnership of Blake & Scott that had supplanted him at Bursledon fared less well. They built three vessels between 1808 and 1812 but were not altogether reliable and incurred penalties for late completion. When the 74-gun *Rippon* was launched in 1812, Richard Blake was heard to say, 'There goes my ruin.' The associated firm of Blake and Tyson initially performed their contracts punctually but the 38-gun *Sirius*, probably the last wooden warship to be built on the Hamble, was launched 14 months late.

Naval shipbuilding ceased at the end of the Napoleonic wars. Merchant vessels continued to be built until the mid-19th century, eventually giving way to the building of small craft. Today, apart from the memorials to the shipbuilders in Bursledon church and the commemoration of the *Elephant* in the name of a boatyard, there are few reminders of what was, in the 18th and 19th centuries, a significant industry. However, the six places where shipbuilding took place are known and are beginning to be explored by the Hampshire and Wight Trust for Maritime Archaeology. Two slips for men-of-war are shown at Brixendone or, to give the place its earlier name, Freehills, on Murdoch Mackenzie's map of Southampton Water of 1783. The same map shows two sites on the eastern bank at Lower Swanwick. These two sites, along with one at Bursledon, are recorded in the *Universal British Directory of Trade, Commerce and Manufacture* (1798) which records: 'Both here [Bursledon] and at the ferry on the Titchfield side, building yards for ships have long been established; and at them and at Upten's

77 *Survey drawing of shipbuilding site at Bursledon Point. The survey was carried out in 2002.*

yard, about a mile above, in the course of the last war … ships were built and launched … Immediately on the conclusion of the war, the two last yards were destroyed; the other is still preserved'. The 'last war' presumably referred to the American War of Independence. It is known that Parsons was building at Bursledon at that time and we can assume that the partnership of John Nowlan and Thomas Calhoun that built the *Unicorn*, *Thalia*, *Woolwich*, *Crescent*, the *Blanche* and the *Blonde* occupied the Swanwick and Freehills sites.

There appear to have been two shipbuilding sites at Bursledon. Part of the waterfront has been obliterated by the building of the railway at the end of the 19th century, but it is believed that Philemon Ewer's yard, and before him Wyatt's, was upstream from the *Jolly Sailor*, in the vicinity of the 'Elephant Boatyard'. (Ewer's house, called Ewers, stands next to the public house.) George Parsons' yard, from which he was forced to move in 1807, was downriver from the *Jolly Sailor*, on the piece of land known as Land's

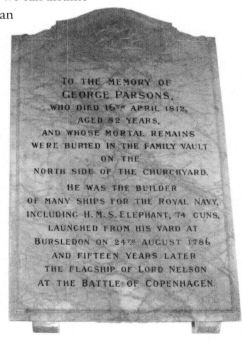

78 *Wall tablet in memory of George Parson in St Leonard's Church at Bursledon.*

End or Bursledon Point. Parsons' new site at Warsash, where he is believed to have built cottages for his workmen and a public house called the *Shipwright's Arms*, and Moody Janverin's yard at Hamble have already been mentioned. It is hoped that all these sites will be surveyed by the Hampshire and Wight Trust for Maritime Archaeology as part of its investigation of the Hamble. They have already surveyed the site of Parsons' yard at Bursledon Point, where the two slipways, probably the same two slipways that Murdoch Mackenzie indicated on the 1783 chart, have been discovered, as well as an upright timber for support and scaffolding. A similar investigation of the site of the George Parsons' yard at Warsash is planned, and it is to be hoped that much more information about shipbuilding on the Hamble will be discovered by the Trust in the near future.

Other Industries: Fishing, Saltmaking, Ironworking and Brickmaking

Man has probably exploited the Hamble for its fish and shellfish ever since the estuary took on its present form, as a result of a post-glacial rise in sea level, towards the end of the Mesolithic. No fisheries are recorded for any of the Domesday manors along the coast – Netley, Hound and Hook – but a medieval 'V'-shaped fish trap has been identified by the Hampshire and Isle of Wight Trust for Maritime Archaeology near the mouth of Dock Creek.

Fish traps of this kind would have provided fish for local consumption, but by this time there are already signs that the river was being used for the large-scale production of shellfish. The monks of Hamble Priory presumably had oyster beds at Hamble, because in the mid-15th century they were supplying St Swithun's Priory with 20,000 oysters each year, during Lent. It's not clear whether these were indigenous oysters or, as was the pattern in later centuries, had been brought from elsewhere to be fattened.

The efforts made by the Corporation of Southampton during the late Tudor period to preserve fish stocks in the Solent and to ensure that the fish that were caught there reached the market in Southampton are recorded in the Admiralty Court Book. The Court issued edicts against the use of certain types of net – presumably those that caught the smaller fish and fry – and the catching of salmon at certain times in the 'blinde streames', including the Hamble or, as it was termed, 'the river going up from Bristleldon river into Botlie and the milwere ther'. A more serious problem for the Admiralty Court was the practice by landowners at Bursledon and Hamble of buying oysters from elsewhere along the coast for onward sale to 'rippers', who carried them inland for sale. Complaints are made in 1577 that John Watering (perhaps the same man who had been asked to acknowledge that he had no right of

way to carry timber through Catland Coppice to the river), Arthur Fry, Thomas Dallimore and Gyles Hault had two illegal coves, and that William Arnolt, James Harrison, Thomas Reads and William Ayles had one cove each on the estuary. Watering and Fry were purchasing large quantities of oysters to store and fatten in their coves, as many as forty thousand a week during the season. During Lent in the year 1584 this had risen, albeit temporarily, to 300,000 oysters a week. An essential part of the objection to such activities was that they were being carried out by middlemen not fishermen using the coves for the storage of their own catches. Thus a complaint is made that 'John Fry, a farmer of Hamble, hath a cove and byes oysters of them that come from the sea and keeps them in his cove and selleth them againe having no crafte at sea at all.'

The practice of 'laying' oysters in the estuary was, it seems, more than a passing phenomenon. In 1748, a John Brett was granted a lease by the Duke of Portland. It included the right of 'carrying and laying oysters to Grow and fatten in the River or Lake … known by the name of Hook River or Lake', the same place that oysters were being laid two centuries earlier.

There were also complaints recorded in the Admiralty Court Book about the construction of fish weirs on the Hamble. John Watering, John Searle of Botley, Thomas Marke, Richard Pitts of Styplecourt and Richard Trebick are reported in 1584 for doing this. They are commanded to pull them down by 'Allhallantide next'. The identities of the landowners and landholdings involved suggest that fish weirs were more a feature of the 'upper' Hamble estuary above Bursledon than the 'lower' estuary.

Hamble itself may have originated as a fishing village though, as will be seen, it may have been a not insubstantial port in the Middle Ages. It was certainly recognised as a fishing village in 1540 when John Leland described it as a 'good fisschar town'; and it has been suggested that Warsash may have had a similar beginning. It seems that by the mid-18th century there was a specialist lobster-fishing fleet operating from Hamble: in a will of 1754 a James Young from the village refers to his Sloop, *James and John*, and equipment used in the 'Lobster Trade'. By 1813, 20 boats were going as far as Land's End and the Scillies to catch lobsters, crabs and crayfish. Throughout the 19th century, vessels from Hamble carried on this trade, travelling to Ireland, Devon and Cornwall as well as, for a time, Norway and Brittany. In the 1890s, there was a motley collection of 22 Hamble river smacks in operation – 'old Essex cutter smacks sold away, others were brought from Chichester Harbour, some were converted yachts and pilot boats' – but this had dwindled to two or three by 1920. At the height of the trade, crabs and crayfish, brought back live in water-filled compartments, were supplied to London hotels and restaurants, as well as to the ocean liners sailing from Southampton. It was also during this period that both Hamble

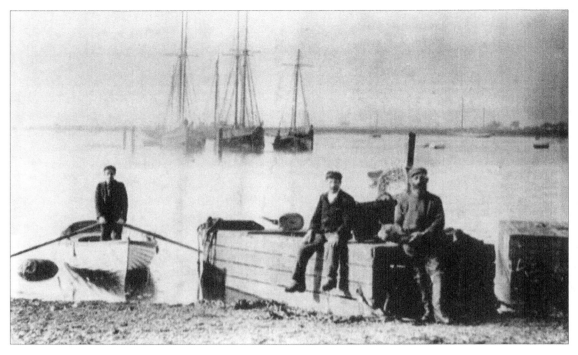

79 *Men sitting on 'carbs' on the Warsash foreshore. These were tarred wooden boxes in which the crabs were temporarily stored.*

and Warsash were renowned for their crab teas. For many years the huge crab pond of James Lock, who owned a tea-room as well as crab boats, was a prominent feature on the Warsash waterfront.

Another fish associated with the Hamble was the whitebait. In *Mudie's Hampshire*, there is what would appear to be a strange, stilted allusion to the annual whitebait dinner that, until 1894, was attended by members of the Government, formerly at Dagenham and latterly Greenwich. 'In the paucity of other piscine delicacies, it is some consolation for the Hantesian mayors and aldermen to know that, by making an annual pilgrimage to the Hamble, between Botley and Hound, they can be daintily refected on white-bait, as the corporation of London, or her Majesty's prime minister himself.' And William Yarrell, in *A History of British Fishes*, claimed that the Hamble was the only southern river from which he had had whitebait, though he attributed this, 'to the want of a particular mode of fishing by which so small a fish can be taken so near the surface, than to the absence of the fish itself'.

The making of salt by evaporation of sea water was another activity carried on by the Hamble, perhaps associated, in part at least, with fishing and the need to preserve the catch. The remains of first-century salt-workings south of Warsash were excavated in 1930 and it is known that salterns at Bursledon supplied salt to the Bishop of Winchester's estates

in the medieval period. It is believed that the riverside area to the south of Bursledon – Hackett's and Lincegrove Marshes – was the site of the medieval salterns, and there is, to this day, a Salterns Lane leading to the riverside there, as well as mounds associated with the old salt works.

The Earl of Southampton's map, showing his estates lying to the east of the Hamble, and believed to date from the early 17th century, shows 'the olde saltern', and what would appear to be evaporation ponds on what is now the site of the Universal Boatyard, just to the north of Crableck Lane. Less than a hundred years later, a map of 1698 shows 'pans' at the mouth of the river, at Hamble point, and Murdoch Mackenzie's 1783 *Survey of Southampton River* shows ponds and associated buildings both here and on the eastern side of the river to the south of Warsash. The salt was made by allowing the sea water to evaporate in shallow ponds until it became strong brine, which was then boiled until only crystals of salt were left. Presumably the 'salthouses' marked on the 1783 chart contained the coal-fired furnaces used to do the boiling.

A tax had been imposed on salt in 1694 and this gave a strong incentive to smuggle it. In 1697 a complaint was made to the Treasury by Arthur Atherley, who was concerned with the saltworks at Lymington, about the unlawful seizure by an Excise Officer of 300 bushels of salt being transported by boat to Botley. In 1715 the proprietor of the Hamble saltworks was caught trying to carry away from his works, by boat under cover of darkness, eight bags of salt, containing 15 bushels, without paying the duty. The same report claimed, '… it is almost impossible for the Officers to wholly prevent the running of Salt from those Works for they stand so near the sea side that if the Officer be ever absent (as he must be to eat and sleep) the proprietors may in that time carry off what quantity of salt they please'. A watchman for the salt works is requested at the 'usual' salary of 7s. a week.

Salt was, it seems, still being made on the Hamble at the beginning of the 19th century. Cobbett, in contrasting the high price of salt with that paid in America, which he attributed to the tax on salt, observed that the salt used at Botley was made 'down somewhere by Hambel', and was purchased from 'our neighbour Warner'. Warner would sell it at 19s. a bushel whereas Cobbett could buy it in America for as little as 2s. 6d. a bushel. It is likely that salt production did not long survive past the date that Cobbett was writing. The duty on salt was abolished in 1825, but the industry was by then in general decline. The process required large quantities of coal and the cost of this made it difficult to compete with producers of rock salt. The evaporation ponds at Hamble Point were subsequently used to keep lobsters and those on the other side of the water appear to have survived in the grounds of the Warsash Maritime Academy.

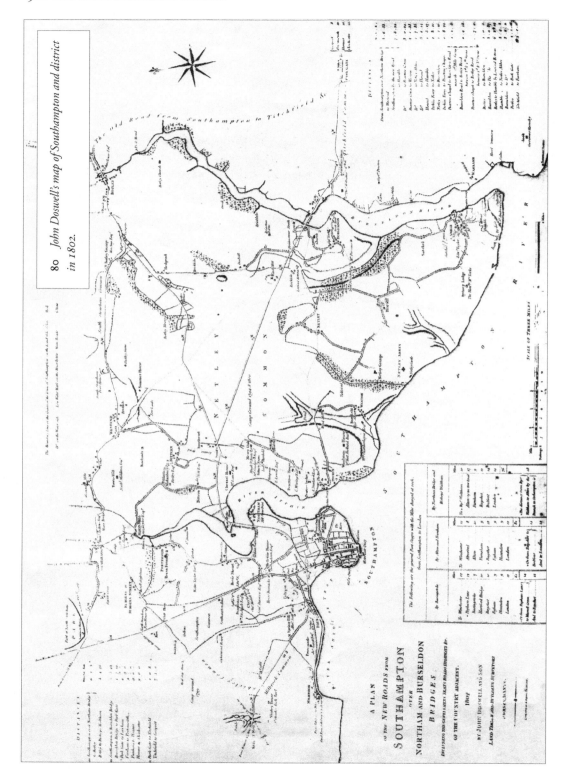

80 John Doswell's map of Southampton and district in 1802.

Another industry that flourished for a time by the Hamble was iron-making. It made use of water power and, in the form of charcoal, local supplies of underwood as well as iron ore from Hengistbury Head. The use of the water wheel had revolutionised iron smelting, causing the process to move from the woods to the waterside. The early 17th-century map that shows 'the old saltern' also shows a new feature in the landscape: the 'Iron myll' at Funtley on the River Meon, which along with the one at Beaulieu had been established by the 3rd Earl of Southampton to improve his finances. By 1606 the Corporation of Southampton is complaining to the government that 'the new erected Iron workes at Bewleu & Tytchfield' were causing, by their rapacious consumption of fuel, a local shortage of wood. The Earl clearly contemplated expanding his iron making operations for in 1608 he inserted in the lease of Botley mill an option to 'determine' it were he to decide to pull it down and erect an ironworks there.

The Earl appears to have quite soon abandoned the direct management of the ironworks at Funtley, leasing it to contractors. From the 1640s, it was being operated by the Gringo family, and members of that family continued to operate the ironworks at Funtley until the latter part of the 18th century, when Henry Cort, 'the Great Finer', took over the business on the death of John Gringo, who we have previously encountered as a purchaser of underwood.

The Funtley ironworks is described in *Titchfield – A Poetical Essay* that was published in 1749:

> *More northward still*
> *Direct your eye along the verdant vale:*
> *Behold what dark'ning Clouds arrest*
> *your view,*
> *And smoky Volumes roll aloft in Air;*
> *There dwells a hardy Race; to fire inur'd*
> *And never-ceasing toil, from Morn to Eve,*
> *Beneath their sturdy blows the Anvils groan*

It is difficult to visualise southern Hampshire as a proto-industrial landscape, but such scenes and sounds – the thumping of the hammers, the smoke rising over the trees – could also be seen even nearer to the Hamble, at Bursledon. The water wheel not only operated the bellows for the furnace, but also the devices for breaking ore and the hammers for beating it once it had been fired. By the early 18th century, John Gringo was, in addition to the Funtley works, operating an iron works on Badnam Creek. A map of the 1720s shows 'Mr. Gringo's Furnice' and it was still there nearly a hundred years later, being shown on John Doswell's map of 1802, and no

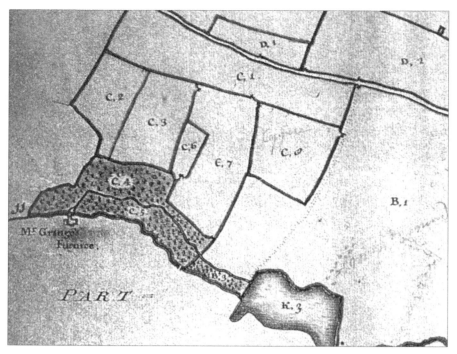

81 *Map of part of Parish of Hound map showing 'Mr. Gringo's Furnice' in the 1720s.*

doubt helping to turn out some of the large quantities of iron nails used in the shipbuilding yards.

It has been suggested that the south Hampshire ironworks should be seen as a westward expansion of the Wealden iron-working region, but, whatever is its larger significance, it was only a passing phenomenon. Another industry had a much longer history and has left more tangible reminders of its presence. It is not surprising that in an area lacking in building stone, the local clays and brick-earth should be used to make bricks and tiles. The Romans had used the local clay to make tiles and pottery and the remains of their brick and tile kilns have been found both at Curbridge and Hallcourt Wood, a little further along the stream that rises near Shedfield and eventually flows into the Hamble at Curbridge Creek. During the 18th and 19th centuries, there were a number of small brick works in the valley, including Dacre's Brickyard at Hedge End and Charlie Churcher's at Durley. The brickyards at Hoemoor Creek, in what is now Manor Farm Country Park, and the confusingly named Bursledon Brickworks at Swanwick, now partially preserved as a museum, made direct use of the river to transport bricks, in the case of the one at Swanwick by sailing barge.

The origins of the Hoemoor brickworks are as yet obscure, but it was in existence by the mid-18th century, when it was being operated by a Henry

Spencer. There are records of the brickworks supplying bricks and lime for the repair of the granary at Botley Farm in 1749, and the bricks, tiles and lime needed to repair Botley Rectory, which still stands in Brook Lane, in 1760. The Hoemoor brickworks ceased operation in about 1908, apparently being unable to compete with the Bursledon brickworks, which had been established by a Mr Ashby in 1897. The buildings that were once on the Hoemoor site – the workers' cottages, kiln and drying sheds – have long since gone. All that remains to remind us of its existence are the declivities marking the old workings in the enveloping woodland and the footings of some of the buildings.

Hoemoor was a small rural brickworks. The Bursledon brickworks that supplanted it was, at least in the later stages of its development, run on industrial lines, producing millions of bricks each year. The clay was extracted using machinery, not dug by hand, and the bricks were dried artificially using a process involving steam. Before this, brick-making was a summer-time activity. However, the great chimneys were to dominate the local landscape for less than a hundred years. The works, by then owned by Redland plc, were closed down in 1974. A number of factors had adversely affected its viability, including a decline in the quality of the clay, problems associated with its extraction, and the interruption caused by the construction of the M27 motorway.

The brickworks at Hoemoor and Swanwick were situated on the London Clay, but the Bishop's Waltham Clay Company, based at Newtown and founded by Sir Arthur Helps, used the Bracklesham and Reading Beds for bricks and tiles and the London Clay for making the hard-wearing blue bricks. At its peak, the works, which were acquired by Mark Blanchard in

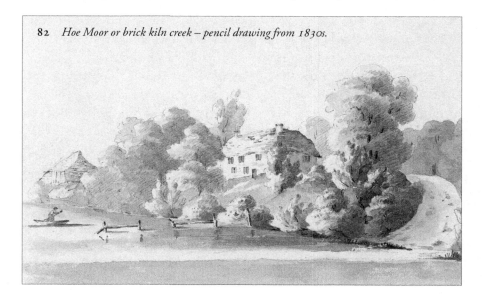

82 *Hoe Moor or brick kiln creek – pencil drawing from 1830s.*

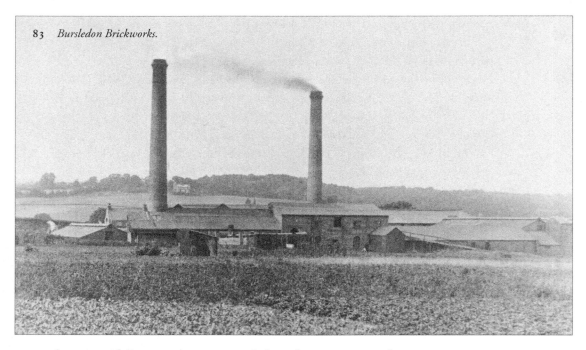

83 *Bursledon Brickworks.*

the 1870s following the company's liquidation, were making a vast range of items: roof tiles, floor tiles, terra-cotta objects, copings, channelling and drain pipes. Blanchard's terra-cotta was incorporated into important buildings such as Buckingham Palace, the Victoria and Albert Museum, the Royal Horticultural Society premises and the Natural History Museum.

THE HAVEN

The history of the non-tidal river above Botley is, to a large extent, the history of the parishes and of the landholdings through which it runs, and its regulation a matter of private law or, in relation to the building and maintenance of bridges, of parish and county administration. When, though, we arrive at the estuary, we are moving into a different jurisdictional and administrative context. Historically, the tidal river had been part of the Port of Southampton. That part of the Hamble river has since 1970 been under the control of Hampshire County Council by reason of the Transport Act 1962. Before that, it was managed by the British Transport Docks Board, which had inherited the function from its 19th-century predecessor, the Southampton Port and Harbour Board. Appropriately for a river like the Hamble, the County Council in its role as harbour authority is concerned with such matters as the provision of harbour facilities as well as conservation and the prevention of pollution.

To understand the meaning of a port in the Middle Ages, and thus the early history of the Hamble, it is necessary to put to one side the mental

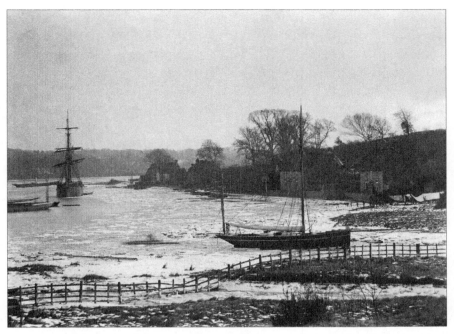

84 *Waterfront at Bursledon in the 1890s. In the foreground is 'Bullock's yacht' in the ice.*

picture of modern port facilities that serve the large ocean-going liners and container ships. A port, as the term would have been best understood in the medieval period, was a stretch of coast, with its harbours and creeks, which also had a legal and constitutional status. Thus a 'port' was not just a matter of physical geography; it was the subject of privileges conferred by charter and statutory rights. Overseas trade could only be transacted in a port. If a vessel engaged in overseas trade were to use a harbour that was not a port, it would be liable to summary arrest. Within a port the vessel would be subject to customs duties, national and local. The Corporation of Southampton,

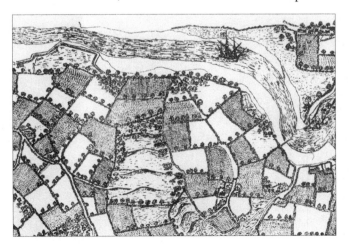

85 *Extract from 17th-century map of valley showing lower part of Hamble estuary.*

in consideration of a fee farm or rent, had been granted the right to collect customs in 1199. The records relating to these, which are only touched on here, provide a fascinating insight into the commercial life of the Hamble during the medieval and later periods.

In 1302 the member ports are said to be Portemue (Portsmouth), Hamele (Hamble), Linnentone (Lymington), Scharprixe (on the eastern bank of the Lymington river) Kyhaven (Keyhaven) and the Rumbrygge (Redbridge). In 1390 a document makes reference to 'the customs [on goods] entering and leaving by sea and by land ... the ports of Portsmouth, Lymington, Keyhaven, Sharprix, Redbridge, Hamble and Hook'. Three hundred years later the port limits, as fixed by an Exchequer Commission in the reign of Charles II, had contracted; Portsmouth was no longer included and Hillhead now marked the eastern-most limit. The Hamble River was unaffected by these alterations and remained within the jurisdiction of the Port of Southampton until the 20th century.

Within the bounds of the port, customs dues were rendered on goods loaded and unloaded. The various Port Books record duty being collected on such items as wine, salt, timber, herring and other fish, such as mulwell (cod) and ray-fish (skate). In 1435-36, for example, customs duty totalling £2 12s. 2d. was collected at Hamble on such commodities as fish, hides, skins, oil and cloths. And in 1448-9, an Antony Nocher pays duty of 10d. on a butt of wine 'diskargat' apd' Hamill'. The right to collect such duty at Southampton and its member-ports was robustly defended by the Corporation. In 1235, it rebuffed a challenge by the burgesses of Dunwich in respect of the arrest by the Mayor and bailiffs of Southampton of the Suffolk ships in the port of Hamble and the taking of customs on herrings and other goods, pleading charters granted by King Richard and King John. In addition to the duties on goods, port tolls were rendered for such things as anchorage and keelage. Thus keelage at 2d. a time was paid by vessels using Hamble and other Southampton member-ports in the 14th century.*

On the Hamble river, only Hamble and Hook have separate identities as member-ports of the Port of Southampton. Although subordinate to the Southampton as the head-port in terms of their status, these were separate customs points where duties were collected either by agents of the Southampton water-bailiffs or by independent persons to whom the right to collect the customs dues had been farmed or let out. In the reign of Edward III (1312-77), the Exchequer queried why detailed records of dues collected at Hamble and other member-ports were not available, and were told by the Southampton administrators that the customs of these ports were 'small and reduced' and

* It has been suggested that keelage was charged in respect of the vessels that came up to the wharves and that vessels that anchored in open water and were unloaded by lighters were charged anchorage dues.

were not sufficient to attract 'a worthy and capable man for their collection'. The 'less worthy men' they were able to appoint could only account in gross for their receipts. It may well have been for this reason that the Corporation often resorted to farming the right to collect dues at the member-ports, rather than trying to collect the revenue itself. Customs at Hamble and Hook were leased in 1390 and those for Hamble farmed in 1426-7 and 1429-30, for example; in 1439-40, Hamble produced in this way income of 4s. 2d.

It has been suggested that after the middle of the 15th century customs of the member-ports were not considered worth collecting, except those of Lymington. Hook seems to have started to go into sharp decline by the late Middle Ages, probably as a result of the silting up of the harbour mouth. Hamble's was less sharp, but by the 16th century, as we have seen, Leland is describing it as a 'good fisschar town', and it appears to have lost some of its medieval pomp. A 1565 survey of the Port of Southampton, 20 years after Leland's account, records that it had only 22 boats and ballingers, six mariners and eight fishermen. But if Hamble had declined, Hook had virtually disappeared. By then, it possessed just two ferry boats, and there were only two fishermen. Yet an analysis of the home-ports of ships that came into the Port of Exeter between 1266 and 1321 has shown that during that period 22 vessels came from Hook and Hamble, whereas only 11 came from Lymington and seven from Southampton. In 1302 a request was made for ships and men from Hamble and St Helens for Edward I's 'Scottish expedition', and for the Crécy Campaign of 1346 Hamble provided seven ships and 117 mariners; Hook, 11 ships and 208 men. The vessels that were arrested for the expedition to Aquitaine in 1450 included three vessels from Hook: the *Christopher*, the *Mary* and the *Margaret*. At 120 tuns, 55 tuns and 80 tuns respectively, these were not insignificant vessels by medieval standards, when small ships were predominant.[*]

It is probable that, with the silting up of the Hook Lake estuary, its maritime interests had migrated to Warsash, which had eight boats, three mariners and six fishermen at the time of the 1565 Survey. Another port on the Hamble River that was operating in the Middle Ages was Bursledon. It was not a member-port of Southampton being exempt from local customs as it was situated in Bishop's Waltham manor, an estate of the Bishop of Winchester. However, vessels from there paid duties on goods unloaded on other parts of the port of Southampton. The *Trinity of Bursledon* was involved in the wine trade in the mid-15th century. And in 1435-6, a duty of 8d. was paid at Hamble on a cargo of cloth carried by that vessel.

The right to farm customs had been granted to Southampton by King John, and it is likely that the Mayor and Burgesses also exercised, in association

[*] See note on p.77.

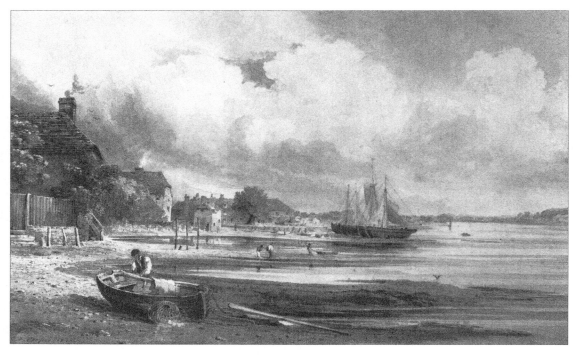

86 *Painting of the Hamble by G.F. Prosser, 1845.*

87 *Bursledon waterside, early 20th-century photograph.*

with this, maritime jurisdiction within the port of Southampton. In 1285 the burgesses destroyed a weir erected by the Abbot of Titchfield at Cadland that was considered harmful to navigation. However, it was not until 1445, in the reign of Henry VI, that the town was exempted from the jurisdiction of the Lord High Admiral. In 1447, the Admiral's powers, including that of holding courts, were granted to the mayor.

The admiralty courts were not held continuously over the centuries. There are records of courts being held at Hamble in 1493 and 1508, but it is unlikely that courts were held between the latter date and 1566. Revived periodically, they fell into disuse in the 18th century, and Admiralty rights were extinguished in 1835. However, a remarkable court book survives for the years 1566-85, recording the activities of the court, and the issues dealt with during that period. These related chiefly to such things as wrecks, navigational obstructions, trade and fishing. The court met at five traditional centres – Southampton, Lepe, Lymington, Keyhaven and Hamble Rise – each one associated with a particular section of coast. The Hamble court dealt with the coast from Netley to Hillhead and covered the whole of the Hamble River up as far as Botley and Curbridge. Each of these courts was held on the sea shore, as was traditional, and the leading mariners and fishermen were summoned to attend before the mayor and town clerk.

The surviving records of these courts, and particularly that of Hamble Rise, provide a valuable picture of the life of the river during the reign of Elizabeth I. The information they contain about fishing, ferries and attempts to prevent the sale of fish outside the usual markets has been drawn on in earlier chapters. Another important concern, of the jurors more than the Corporation, was the prevention and removal of obstructions to navigation on the river. There are, in this regard, numerous presentments to the court about weirs, fallen trees and jettisoned ballast. In August 1575, for example, a protest is made about the 'stonnes and balliste throwen at Burseldon to the grete a noyaunce of the Haven'. In 1580, it is claimed that a 'Mr. Pett of Sepell court [Steeple Court, a mile below Botley] doth anoy the haven with tymber and other wood', though it is not clear whether these are fallen trees or the river is being used to transport timber.

The Hamble continued to be used for overseas trade after the Middle Ages, as we saw in an earlier chapter. In 1700, the *Mary Anne* of Warsash, captained by an Israel Brown, a local man, even undertook an ill-fated slaving expedition to the Guinea Coast of Africa. In later centuries, the Hamble appears to have been much used by those seeking to avoid customs duties altogether. There are numerous references to smuggling in and around the estuary. In 1700 the Treasury requested the Customs Service to employ a small boat of about 5 tons around the mouth of the Hamble 'there being frequent informations

of great quantities of wines and other goods being run in Southampton water'. This and the fact that 10 Dragoons were stationed there in 1723 to help combat the running of contraband suggests that it was something of a smuggling hotspot. In 1773, Mr Morse, the riding officer at Hamble, seized 300 gallons of brandy and two hundredweight of tea. Later the same year Mr Morse and another officer seized 101 kegs of liquor, which they secured in a boat. They did not keep it all for long – '… the officers being pretty much fatigued,

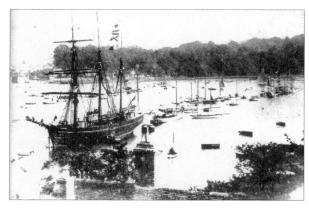

88 *Photograph of the lower estuary in the late 19th century. It is believed that the larger vessel is the* Waterwitch, *which was carrying coal.*

went to refresh themselves at a public-house; in the mean while the smugglers broke open the cuddy of the boat wherein the seized goods were deposited, and took out 51 of the kegs, with which they got clear off'.

It was a typically 18th-century display of contempt for authority and this, coupled with the large quantities seized, indicates that the customs

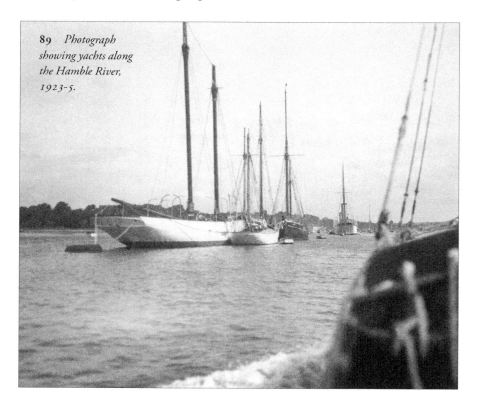

89 *Photograph showing yachts along the Hamble River, 1923-5.*

officers were dealing with a serious smuggling gang, perhaps that of Sturgess of Hamble, a well-known smuggler who operated in this area at the time. It is probable that smugglers regarded the Hamble as a convenient smuggling location, as, like the Beaulieu, it was a quiet river along which the contraband could be quickly conveyed a fair distance inland, perhaps using one of the small lighters that plied along it.

TWENTIETH-CENTURY RIVER

The village of Hamble lies upon the Hamble River, a tidal tributary of Southampton Water ... In the last century Hamble was a fishing village; by 1914 it had become a prosperous centre for the building, fitting out, and laying up of yachts.

Nevil Shute, *What happened to the Corbetts*, 1939

I described the present-day Hamble perhaps a little too dismissively as a 'leisure river' in the opening chapter and thereby overlooked, at least temporarily, that the commercial and other activities that are now carried on along its lower reaches are not fundamentally different from those of the past, and have evolved from them. Nonetheless, there have been great changes on the river in the last hundred years or so, and no more so than on the lower estuary.

The river that Commander C.E. Eldred depicts in his *Yachting Monthly* article of 1912, with the assistance of sketches of scenes from along its banks, seems a quiet backwater, and its development as a yachting centre, which has

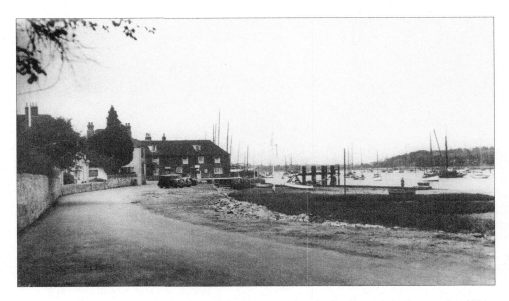

90　*The Hamble. Taken before the Second World War, when the foreshore was built up with rubble from the air raids.*

dominated its 20th-century history, was still very much in the future. This is not to say that yachting was not in evidence by then. Eldred noted vessels on the estuary 'ranging between a 1,400-ton steam yacht and 14-ft centre-board dinghy' as well as 'the grey hulks' of corvettes and gunboats that he had seen under sail in the China seas. The large steam yacht referred to may have been the 1,800-ton *Triad*, which was moored on the river at this time.

The grey hulks Eldred mentions were almost certainly the Boom defence vessels. These old vessels were linked together and could be towed into position to protect the Port of Southampton from attack from the sea. The commander of the Boom defence was a Mansfield George Smith Cumming (1859-1923), who was later to be an intelligence officer in the secret service bureau. It was Smith Cumming who was responsible for another feature of the river at that time that was noted by Eldred. He had arranged for the mast of HMS *Sultan*, one of the first ironclads, to be placed in the river at the entrance to Badnam Creek as part of the Boom defence pier. The mast was simply dropped into the river, its own weight taking it down half its length into the soft mud.

Such military activity was an intermittent phenomenon that was to be repeated again during the Second World War, but yachting, on the other hand, has been a significant presence on the river since the end of the 19th century, and grew rapidly in the period up to the Second World War. It is no coincidence that Peter Corbett, the Southampton solicitor hero of Nevil Shute's 1939 novel, *What happened to the Corbetts* (a book that anticipated effects of the Blitz and gives some idea of the character of the Hamble in the

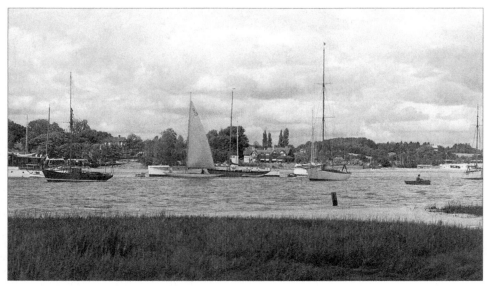

91 *Lower estuary in the 20th century.*

1930s), should keep his 'nearly forty years old … gaff-rigged cutter' on the river. The Hamble was popular with yachtsmen for some of the reasons it had been favoured by shipbuilders in earlier centuries: it was sheltered from the westerly winds and was in a good geographical location. A number of yacht clubs soon sprang up. The Minima Sailing Club had been formed in 1889 and, after a hiatus caused by the First World War, the Hamble River Sailing Club was formed in 1919. Its objects included the encouragement of 'the sport of small boat sailing and racing'. In 1936 the Royal Southern Yacht Club, which had been founded in 1837, moved from Southampton to the premises (formerly a row of cottages) that it still occupies on the Hamble waterfront.

The inhabitants of the valley soon adapted themselves to the new enthusiasm for yachting. The Hamble fishermen found employment as yacht skippers during the summer months, thereby supplementing their earnings with an employment less arduous than sea fishing. They were also key participants in the regattas held at Hamble and at Bursledon and Swanwick since at least the 1870s. These involved sailing and rowing races, and the fishermen would have provided expertise at such events. The adaptability of local businesses to a changing environment is exemplified by that of A.H. Moody & Son. Founded by a John Moody in 1827, it began as a small boatbuilding business, constructing and repairing Warsash crabbers and other small vessels. They also repaired the lighters belonging to the Mears family that have been mentioned in an earlier chapter and, as George Parsons had done in the 19th century, repaired the wooden bridge at Bursledon. In the 1930s, Moody's, having previously only made fishing boats and dinghies, started to build yachts. To begin with, these were built bespoke for individual purchasers. They included a motor yacht called *Lady Cristabelle*, which was to participate in the evacuation of Dunkirk, returning safely. The company ceased to build wooden yachts after 1970 and turned its attention to the building and fitting out of glass fibre yachts and motor yachts.

With the outbreak of the Second World War, there was a cessation of yachting activity on the river, with most yachts being immobilised, and it again assumed its military role. HMS *Tormentor*, a shore base for repair and maintenance, was established at Warsash. There was also a base for motor launches, motor torpedo boats and other small craft on the site of what is now the Universal Boatyard at Sarisbury. Moody's workforce assisted with the repair and maintenance of the landing craft and other vessels. Landing craft based on the Hamble took part in the ill-fated raid on Dieppe in 1942. The workforce arrived at work on the day after the raid to find shot-up landing craft, still with live ammunition, in the now filled-in creek by the yard. The Hamble also witnessed the early trials of the first midget submarine. It was

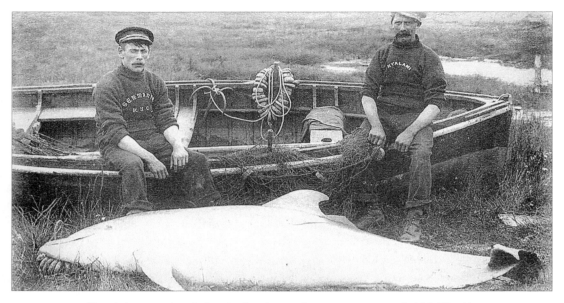

92 *'Porpoise', measuring 8 feet in length, caught on upper part of tidal Hamble. The creature is probably a Bottlenose dolphin,* Tursiops truncatus.

launched on the river in 1943, and taken out from the river to open water to be put through its paces.

During the run up to the D-Day landings of 1944, military and naval activity intensified on the river as in much of south Hampshire. HMS *Cricket* had been established in the woodland to the north of Hoe Moor Creek to provide training in the use of small landing craft. In the early months of 1944, the flotillas of landing craft that were destined for the Gold and Juno beaches on the Normandy coast were assembled there. They left the Hamble on 5 June 1944 and many did not return; indeed, on account of the unexpectedly rough weather that night, some of the craft did not even survive the channel crossing. Another 3,000 commandos embarked at Warsash.

After VJ Day, HMS *Cricket* became a transit camp for servicemen returning from abroad before finally being closed in 1946. The remains of some of the camp's buildings can be seen in the woodland that now forms part of the Manor Farm Country Park.

The river above Bursledon had another, slightly surreal function during the Second World War. Probably because of the similarity in the shape of the Hamble to the Itchen at Northam, 9 acres of land at Marks Farm were commandeered as a bomb decoy site. The idea was that fires were lit during air raids to mimic the effect of incendiary bombs and thereby convince enemy pilots that they were on target. They would then drop their bombs harmlessly on open land. Ironically, though, fewer bombs seem to have fallen on the fields of Marks Farm after the decoy site had been established.

Following the end of the war, there was another surge in the popularity of yachting, and there has been little abatement of such popularity up until the present day. This is borne out by the number of yachts moored on the Solent. Before 1939, there were fewer than 3,000 yachts in all of its harbours; now there are more than 3,000 pleasure craft moored on the Hamble itself. This has spawned further development on the river such as a substantial marina developed by Moody's in the 1960s. Other marine-related development along the river includes the Warsash Maritime Academy (formerly the School of Navigation and College of Maritime Studies), which had been established on the HMS *Tormentor* site in 1946. This continues the use made of the river for such training that was first established when the Training Ship *Mercury*, the nautical school that had been established by the banker Charles Hoare in 1885, moved to the river from Binstead on the Isle of Wight in 1892. Based at Mercury House, just to the north of Hamble, and a three-masted barque called *Mercury*, it was for many years overseen 'with a rod of iron' by the formidable 'Beatie', Mrs Fry, the wife of C.B. Fry, the great sportsman, who, prior to her marriage, had been Hoare's mistress for many years, bearing him two children. The *Mercury* closed in 1968 and all the buildings, including a theatre based on Wagner's theatre at Bayreuth, have long since disappeared, though the

93 *Watercolour by Anne Hayward illustrating the upper reaches of Hamble estuary.*

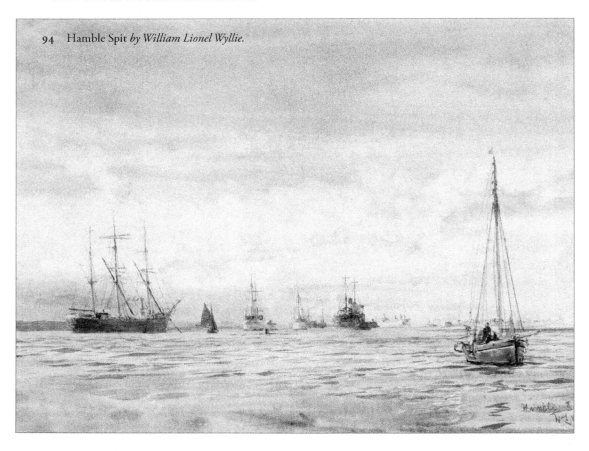

94 Hamble Spit *by William Lionel Wyllie.*

names Fry and Mercury are commemorated in the road names of some of the new housing that has been built on its site.

The developments on the river have been matched by a steady development of the surrounding area. The Hamble and Warsash areas have been heavily developed for housing and industry. The Hamble estuary will never become an urban river like the lower Itchen. Not only is too much riverside land in public ownership – large areas belong to Hampshire County Council and the National Trust and are nature reserves – but there has developed an increasing awareness of the river's importance, both in terms of its scenery and ecology. The main river channel and the marshland are protected by a plethora of conservation designations, SSIs and Special Protection Areas, and even, in the case of much of Hamble Common, as a Scheduled Ancient Monument. The activities of the Hampshire and Wight Trust for Maritime Archaeology over the last 10 years or so have done much to highlight the historical importance of the Hamble.

95 *Early 20th-century view of the Hamble from Satchell Marsh, on the west bank. The TS* Mercury *is in the background.*

The idea of a 'Solent City' stretching between Southampton and Portsmouth has long since been consigned to the planners' and politicians' dustbins, but it is likely that during the next fifty years or so the valley will be subjected to further extensive development. Even as I write these last pages, large development schemes are being proposed at Boorley Green, adjacent to the Ford Lake tributary of the Hamble, Bursledon and North Whiteley, the latter being close to the land that Hugh Jenkyns helped preserve in the 1920s. There is also still the possibility of gravel extraction on the Hamble Airfield site. Whilst it is hoped that the main river, and its immediate environs, will be secure, it is likely that there will be increased urbanisation of its hinterland. (Indeed, the development proposed at Bursledon is adjacent to the river.) This will undoubtedly erode its special character and any feeling of local distinctiveness. It has been said that it is impossible now to write about a place without adopting a tone of elegy, of proleptic sadness. And indeed it is very difficult here on the banks of the Hamble, in the pressured south-east of England, to disagree with that view.

SELECT BIBLIOGRAPHY

Anderson, R., 'English Galleys in 1295', *Mariner's Mirror* (1928)

Biddell, B., *Bishop's Waltham – A History* (2002)

Biddell, B., *The Jolly Farmer? William Cobbett in Hampshire, 1804-1820* (1999)

Bond, D., 'Hampshire's Iron Age', *Hampshire Archives Trust Newsletter* (2002)

Bourke, W., 'Discovery of an Ancient British Canoe in Hampshire',
 Hampshire Field Club and Archaeological Society ('HFCAS') Proceedings (1889)

Bridges in Hampshire of Historic Interest (2000)

Chapman J. and Seeliger, S., *A Guide to Enclosure in Hampshire 1700-1900* (1997)

Chun, D., 'Hoop-making in the Hamble Valley', *HFCAS Newsletter* (1987)

Chun, D., 'Hards, quays and landing spaces on the "Upper Hamble" ',
 HFCAS Newsletter (1997)

Chun, D., 'The Hamble Navigation', *HFCAS Newsletter* (2006)

Cobb, H., *The Local Port Book of Southampton 1439-40* (1961)

Cobbett, W., *The Woodlands* (1828)

Cobbett, W., *Rural Rides* (2001 edn)

Cunliffe, B., *Facing the Ocean – The Atlantic and its Peoples 8000 BC-AD 1500* (2001)

Currie, C., 'Botley Manor Farm's woodlands in the 18th century', *HFCAS Newsletter* (1991)

Currie, C., 'Sea Ponds, with reference to the Solent, Hampshire' in Aberg, A. and Lewis, C.,
 Rising Tide – Archaeology and Coastal Landscapes (2000)

Davies, J., *A History of Southampton* (1883)

Draper, J., 'Mesolithic Distribution in South-East Hampshire', *HFCAS Proceedings* (1964-6)

Drummond, M. and McInnes, R. (ed.), *The Book of the Solent* (2001)

Ekwall, E., *English River-Names* (1960)

Ellis, M., *Water and Wind Mills in Hampshire and the Isle of Wight* (1978)

Foster, B., *The Local Port Book of Southampton for 1435-36* (1963)

Fox, C., 'A Bronze Age Refuse Pit at Swanwick, Hants', *The Antiquaries Journal*, VIII (1928)

Fox, C., 'The Bronze Age Pit at Swanwick, Hants. Further Finds',
 The Antiquaries Journal, X (1930)

Friel, I., 'Henry V's *Grace Dieu* and the wreck in the R. Hamble near Bursledon, Hampshire',
 The International Journal of Archaeology (1993)

Friel, I., *The Good Ship – Ships, Shipbuilding and Technology in England, 1200-1520* (1995)

Furley, J., *Quarter Sessions Government in Hampshire in the Seventeenth Century* (1937)

Hammond, J., *The Paper Mill, Curdridge, Hampshire*, Durley History Society Booklet No. 7 (2009)

Hampshire and Wight Trust for Maritime Archaeology, *Hamble River Logboat: Report on Recent
 Investigation by HWTMA* (September 2010)

Hampshire and Wight Trust for Maritime Archaeology, *Recording Archaeological Remains on the River Hamble* (2008)

Harrison, D., *The Bridges of Medieval England – Transport and Society 400-1800* (2004)

Hoare, P., *Spike Island – The Memory of a Military Hospital* (2001)

Hogg, J., *Curdridge and Saint Peter's Church* (1988)

Holland, A., *Ships of British Oak – The Rise and Decline of Wooden Shipbuilding in Hampshire* (1971)

Holmes, A., 'A Romano-British site at Shedfield, Hants' *HFCAS Proceedings* (1989)

Holt-White, R. (ed.), *The Life and Letters of Gilbert White of Selborne* (1901)

Hughes, M., 'New Evidence of the Romano British Site at Fairthorn, Botley', *HFCAS Newsletter* (1972)

Knight, R., ' "Devil bolts and deception?" Wartime naval shipbuilding in private shipyards, 1739-1815', *Journal of Maritime Research* (2003)

Kowaleski, M. (ed.), *The Local Customs Accounts of the Port of Exeter, 1266-1321* (1993)

Lewis, E., *The Southampton Port and Brokage Books 1448-9* (1993)

'Life of Robert Stares, of Botley', *The Hampshire Repository*, volume II (1801)

March, E., *Inshore Craft of Great Britain – In the Days of Sail and Oar*, Vol. II (1970)

Moody, A., *Boatbuilding on the Hamble River – A Short History of A.H. Moody & Son* (1988)

Moore, J., 'Bursledon Bridge', *HFCAS Newsletter* (1995)

Moore, P. (ed.), *A Guide to the Industrial Archaeology of Hampshire and the Isle of Wight* (1984)

Morley, G., *Smuggling in Hampshire and Dorset 1700-1850* (1983)

Mott, R. and Singer P., *Henry Cort: The Great Finer* (1983)

Page, M., *The Pipe Roll of the Bishopric of Winchester, 1301-1302* (1996)

Page, M., *The Pipe Roll of the Bishopric of Winchester 1409-1410* (1999)

Pannell, J., *Old Southampton Shores* (1967)

Piggott, S., 'The Bronze Age Pit at Swanwick, Hants: A Postscript', *Antiquaries Journal* (1963)

Prior, F., *Britain BC – Life in Britain and Ireland* (2003)

Rackham, O., *Woodlands* (2006)

Ritchie, S., *The Hamble River and much about Old Bursledon* (1996)

Roberts, E., 'The Bishop of Winchester's fish-ponds in Hampshire 1150-1400', *HFCAS Proceedings* (1986)

Roberts, E., 'The Bishop of Winchester's deer parks in Hampshire 1200-1400', *HFCAS Proceedings* (1988)

Robinson, N., *Hamble – A Village History* (1987)

Rose, S., *Southampton and the Navy in the Age of Henry V* (1998)

Rose, S., 'The Port of Southampton in the Fifteenth Century: Shipping and Ships Masters', *HFCAS Proceedings* (2006)

Ross, A., *Pagan Celtic Britain – Studies in Iconography and Tradition* (1974)

Satchell, J., *The Hamble River Project – 2nd Interim Report* (2002)

Satchell, J. and Stone, G., *The Hamble River: Maritime Archaeology Foreshore Companion* (2005)

Schama, S., *Landscape and Memory* (1995)

Shorter, A., 'Paper-mills in Hampshire', *HFCAS XVIII*

Soffe, G. and Johnston, J., 'Route 421 and other Roman Roads in South Hampshire' in Hughes, M. and Lewis, E. (ed.), *Rescue Archaeology in Hampshire Number, 2* (1974)

Stone, L., *Family and Fortune – Studies in Aristocratic Finance in the Sixteenth and Seventeenth Centuries* (1973)

Stapleton, B. and Thomas, J. (ed.), *The Portsmouth Region* (1989)

Struder, P., *The Port Books of Southampton, 1427-1430* (1913)

Tattersfield, N., *The Forgotten Trade* (1991)

Thompson, E., *Whigs and Hunters – The Origin of the Black Act* (1985)

Toghill, P., *The Geology of Britain – An introduction* (2003)

Tomlin, R., 'Roman Britain in 1996 (2), Inscriptions; Hamble estuary', *Britannia* (1996)

Trinder, H., 'The Hamble River', *HFCAS* Proceedings VI (1909)

Tubbs, C., *The Ecology, Conservation and History of the Solent* (1999)

Universal British Directory of Trade, Commerce and Manufacture (1798)

The Victoria County History of Hampshire (1903-14)

Walford, M., 'Bursledon's Toll-free Bridge', *HFCAS Newsletter* (Spring 2010)

Welch, E. (ed.), *The Admiralty Court Book of Southampton 1566-1585* (1968)

Whittaker and Lashmore, *Bursledon Village and Bridge* (1930)

Willan, T., *River Navigation in England* (1964)

Woodford, B., *Warsash and the Hamble River – A History and Guide* (2006)

Wymer, J., *The Lower Palaeolithic Occupation of Britain* (1999)

USEFUL WEBSITES

Hampshire and Wight Trust for Maritime Archaeology – www.hwtma.org.uk
This invaluable website contains a wealth of material about the Trust's investigations throughout the Solent. The section on the Hamble River Project enables information about the river to be located by place, theme and period.

Old Hampshire Mapped – www.geog.port.ac.uk/webmap/hantsmap
This well organised website contains reproductions of historical maps of Hampshire.

DOCUMENTS REFERRED TO IN TEXT

BRITISH LIBRARY, LONDON

Additional MSS 22906-7, letters from William Cobbett to John Wright.
Additional MSS 37853, letters from William Cobbett to John Windham.

HAMPSHIRE RECORD OFFICE

WRIOTHESLEY COLLECTION

5M53/1114/2 – Letter from Clement Walcot to John Lucas, 1742

5M53/1128/11 – Letter from Clement Walcot to Robert Harley, November 1757

5M53/1345 – Extracts from Court Books & Registers of Titchfield Estates

5M53/1110/6 – Letter from Robert Fielder to John Lucas, 1742

5M53/1104 – Letter from Gilbert Jackson to John Lucas, 1735

5M53/1112/30 – Letter from Clement Walcot to John Lucas, 9 November 1741

5M53/1110/6 – Letter from Robert Fielder to John Lucas, November 1742

5M53/1130 – Account of coppice wood sold in Swan Coppice and Bushy Coppice in 1756/57, October 1759

5M53/1125/5 – Letter from Robert Fielder to John Lucas, October 1754

5M53/1111/41 – Timber on several Farms on Titchfield Estate, 1740

5M53/1141/1-3 – Account of expenditure

5M53/118 – Letter from Briggs Souter to John Lucas, 1747

5M53/1123/68 – Agreement for sale of underwood in Maids Garden Coppice, 1752

5M53/1143 – Account of timber sold 1752-1768

5M53/1116/28 – Letter from Robert Fielder to John Lucas, 1745

5M53/1119 – Letter from Robert Fielder to John Lucas, April 1748

5M53/1119 – Letter from Robert Fielder to John Lucas, September 1748

Waller Papers

29M67/5, 6, 7 and 10 – Notebooks and account books

Other

11M59/155643 – Register of leases 1660-1664

5M50/2102 – Letter from John Gringo to Thomas Puckeridge, 1772

45M72/M8 – Notes of Warner family transactions mainly concerning woodland, 1837-1857

20M75MF1 – Will of James Young, 1754

Institution of Civil Engineers

REN/RB/02/170 – Report by John Rennie on bridges at Bursledon and Northam, 1800

National Trust for Places of Historic Interest or Natural Beauty

Correspondence and other documents relating to The National Trust's acquisition of land on the River Hamble.

The National Archives

SP12/38 – Survey of Port of Southampton, 1565

T4/7, 249 – Petition to Lords of the Treasury, 1697

T54/23, 148 and 149 – Letter from the Salt Office, 1715

INDEX

Visit our website and discover thousands of other History Press books.

www.thehistorypress.co.uk

Printed in Great Britain
by Amazon